NOTTINGHAM
THROUGH TIME

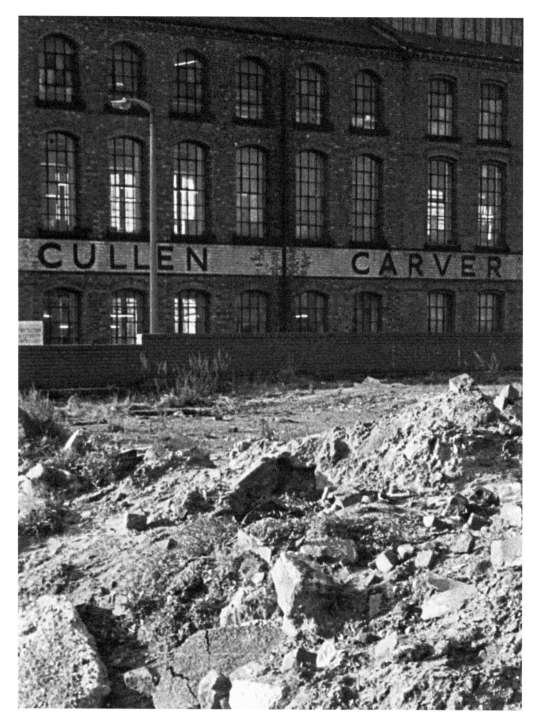

Cullen's Cardboard Box Factory, Mount Street, Basford, 1988. Situated in the Northgate area of Basford, this old factory also bears the lettering 'Papyrus Works' high up on its walls.

NOTTINGHAM
THROUGH TIME

Chris Richards

AMBERLEY

Dedication

This book is dedicated to my late brother Harry Richards (1942–2008).

First published 2008

Amberley Publishing Plc
Cirencester Road, Chalford,
Stroud, Gloucestershire, GL6 8PE

www.amberley-books.com

British Library Cataloguing in Publication Data.
A catalogue record for this book is available from the British Library.

ISBN 978 1 84868 068 5

Typesetting and Origination by Amberley Publishing.
Printed in Great Britain.

Contents

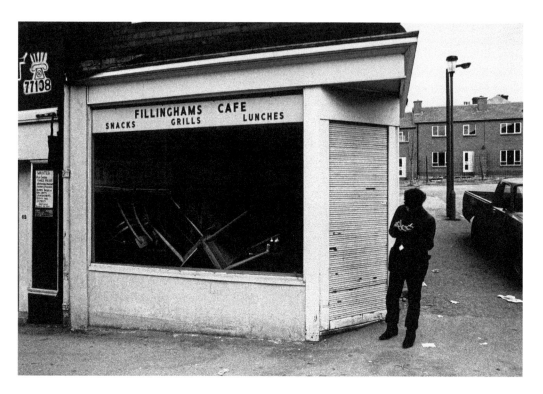

Fillingham's Café, Radford Road, Hyson Green, 1981. Fellow art student Paul Fillingham is standing outside the café at the Hawksley Road junction which shares his surname. This corner shop was previously Gray's ladies outfitters. The junk shop to the left is asking for 'all good three-pieces'. Note the brown and red squeezy bottles of ketchup in the shop window, an essential embellishment for the perfect fry-up.

Acknowledgements

I would like to thank the following organisations and individuals who have been in involved in the production of this book: The Radford Local History Society, Nottingham Local Studies Library, Paul Fillingham, Keith Dudley, Helen Carlin, Peter Clark, Brenda Rosian, Brian Richerby, Dawn Finch, Jane Turner Goodwin, Jill Pumfrey, and my wife Deborah, who helped out with paper clips, scissors and captions as we made the first steps towards assembling this book and later on, helped to identify the various flavours of Apollo soft drinks from our childhood!

Introduction

One of my late father's first memories was of the construction of Nottingham's Council House in the late 1920s. He told me how he stared wide-eyed at the great dome-like structure rising into the sky like a moon rocket. Gangs of labourers wearing flat caps balanced precariously on wooden planks as they bolted the framework together. Another time, he told me a story how he and his friends had learned to swim by jumping into the Nottingham Canal at Wollaton, but warned me never to attempt anything quite so stupid and dangerous myself.

My parents' first camera was a folding Coronet model, which was only pulled out of its brown leather case during holiday times and for special occasions. Parents would relay instructions to the group being photographed while they grappled with the camera and shouted 'Don't say "cheese" until I've got the sun behind me'. Film would often remain in the camera for a year or more, until it was used up and taken to the local chemist for developing. Family photographs were stored in an old shoe-box in the sideboard, and each one had the year and location recorded on the back with a blue Biro pen.

At this time, around the mid 1960s, the large-scale clearance of unfit houses had already started around Nottingham, and I can remember as a child, being fascinated by the demolition gangs' ball and chain, which seemed to make light work of destroying the ancient terraces, smashing through rotten timbers and crumbling bricks, multi-coloured ancient wallpaper being juxtaposed like an abstract painting as rooms lay open to the sky, net curtains flapping in the wind. The empty streets became avenues of tin, swiftly nailed over windows and doorways, to prevent unauthorized occupancy by vagrants or drifters. As I wandered these forgotten streets as a child, I wondered who had lived in these houses and what they had done. Where had they all gone?

Many council tenants found themselves rehoused in high rise blocks of flats, a hundred feet up in the sky, isolated from family and old neighbours whom they had known for generations. As old streets were razed and cobbles covered in tarmac, new houses were built in their place. The late 1960s saw the demolition of Nottingham's Victoria Station and the decaying St Ann's area, and the construction of many modern housing complexes and shopping precincts, some of which used the Victoria Station rubble as hardcore for the foundations. The Clifton estate, in particular, was at one time, the largest council estate in Europe.

In summer 1965, we were lucky enough to be allocated a house on Ainsley Road, Radford, enclosed by privet hedges, with hot and cold running water, a garage, and a lockable shed and coal-house! The school and local swimming baths were nearby, as were the off-licence, newsagents, butchers and chip-shop. The local Chinese takeaway offered a tasty alternative to Friday night Vesta ready-meals. As I got older and ventured into town on Saturdays with my friends, I took in all of Nottingham's shops, bars, and pubs. Some shops were vast; 'Marks and Spencer' (nicknamed 'Marks and Sparks' by my parents), and Woolworths, (also nicknamed 'Woolies'). However, Nottingham at that time seemed a little tired and in need of refreshment.

When I started taking my first photographs around Nottingham in the late 1970s, SLR cameras were expensive, large and heavy, and black and white film was notoriously difficult to process. I managed to save for my first camera in 1981, during my first year at college, by surviving on cabbage, Pot Noodles and coffee. At one point, in the 1980's, I was running a whole 36-exposure film through my Pentax each day, and the recording of images became almost obsessive. A lot of Sundays were spent in Nottingham's Old Market Square, where I would wander round with the camera, as back then, no shops would be open and I had nothing better to do with my spare time.

The temptation of cheap imported goods and demise of manufacturing industry in the 1980s led to many old factories becoming derelict, but most of these have found a new purpose as modern apartments for urban living, and a whole new generation of students and workers have now become 'city dwellers'. In turn, the 1960s concrete hi-rise solutions became modern slums themselves, and flat complexes such as Basford, Balloon Woods, and Hyson Green were pulled down, and replaced by streets of new terraced town-houses.

In 2003, the trams returned to the streets of Nottingham, offering a cleaner mode of transport, servicing many areas of the City, including Hyson Green, Basford, Bulwell and Hucknall, There are plans for more new lines branching out into other areas before too long.

Nottingham pubs and restaurants now offer a greater variety of food than ever before, a far cry from the Berni Steak Houses of the 1970s, and the live music scene seems to be as vibrant as ever, with venues such as The Rescue Rooms, Rock City, and the huge Trent FM Arena playing host to many major artists. However, the recent smoking ban and availability of cheap supermarket alcohol has hit the pub trade hard, leaving many as boarded-up shells, furnished with 'To Let' or 'For Sale' boards.

Perhaps it could be argued, that the new Nottingham, with its chains of coffee shops, fast-food outlets and bars on every corner, has lost something of its former character. Revolutionary construction materials and techniques have made the erection of large buildings much easier, and Nottingham certainly seems to be developing at an alarming rate, as we gaze up at the cranes populating the Nottingham skyline. Moving on a quarter of a century from when I first looked through the lens and clicked the shutter, everybody now seems to have access to digital photography, or even a camera built into his or her mobile phone. In the future, however, Nottingham residents will have thousands of images to show to their grandchildren, digitally perfect and saved to DVD, not just a shoe-box full of fading prints.

I have included some quite recent 'old' and 'new' photographs in this collection, just to show just how fast the City is changing. But in time, even my most recent pictures will I guess, themselves become history and hold their own special memories.

I hope you thoroughly enjoy my trip 'Through Time'.

Chris Richards

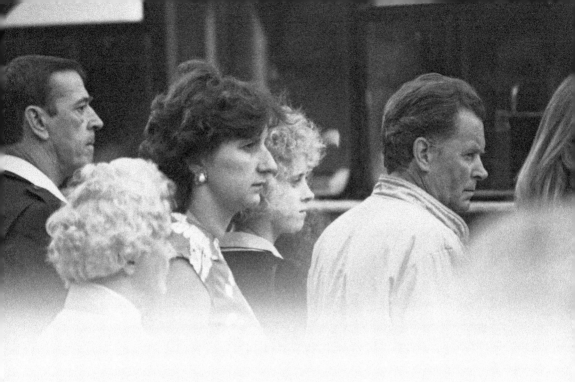

chapter 1

People

Norton Street, Radford, 1956. Brenda Morley is standing with Carroll, the family milkman. 1950s milkmen seemed to be a species all of their own, with their leather satchels full of coins and neatly marked-up payment books ready to hand, with cigarettes dangling from their bottom lips.

Norton Street, 2008. Most of the old mill buildings seem to have survived the demolition gang's ball and chain, including the bay window at the rear of Hollin's Mill, also known as 'Merino Mill'. This road is strangely quiet now, but fifty years ago it would have hummed with activity from Holt's machine manufacturers, Day's cane furniture makers, and Manlove and Alliot's engineers. The 'Globe' pub is at the end of this street (see page 55) as is the blue-capped Woodlands flats complex.

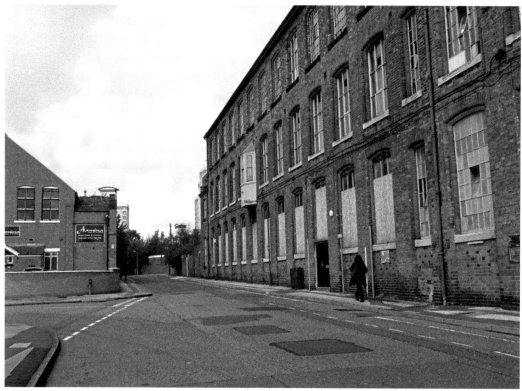

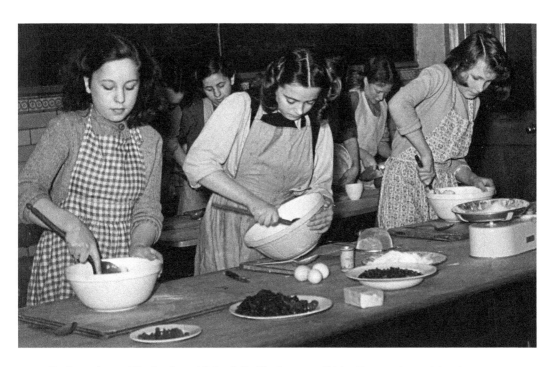

Cookery class at The Boulevard School, Radford, 1949. Shirley Pearson (centre) is using a traditional mixing bowl, possibly to make a rich fruit cake.

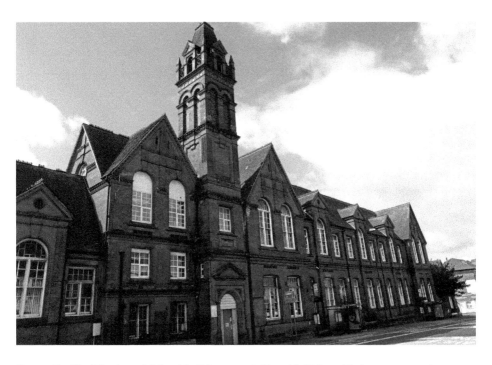

Former Radford Boulevard School building, 2008. The old Girls and Infants entrance is indicated by the green door. Today the building functions as a community centre.

Vincent Greenacre (left) and Pete Atkin, Ainsley Road, Nottingham, 1982. The Ainsley council estate was built just after World War Two, and is situated between Western Boulevard and Radford. At this time, the estate boasted a Co-op store, Wilson's Off Licence, and a small row of shops opposite where Vincent and Pete are standing. I lived on this estate from 1965 to 1994.

Ainsley Road, 2008. This estate new consists mainly of ex-council properties, and the shops opposite have been converted into flats. Former residents may remember them as Les's greengrocers' shop, the Spar Store, Selvey's Butchers and Len's Chinese Takeaway, which was the only shop in operation on the estate during the 1970s power strikes, as his range was powered by gas.

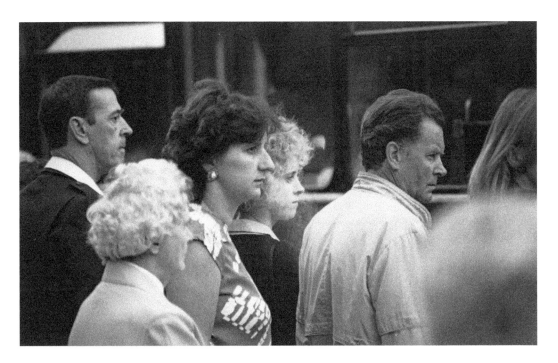

Shoppers crossing Parliament Street, Nottingham, 1984. Although no shops are visible on this shot, it was almost certainly taken on the Clumber Street crossing as a Nottingham bus passes the junction.

Parliament Street, Nottingham, 2008. Clumber Street, in the distance, was formerly called Cow Lane. All three pubs on this street: The Lion, The Crystal Palace, and The Old Corner Pin, have been converted into shops, and the road is now pedestrianised.

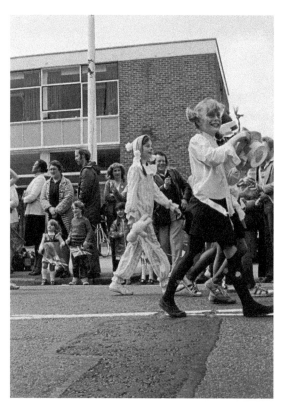

Long Eaton Carnival procession, Tamworth Road, Long Eaton, 1981. This district was a popular choice for factory workers relocating from Nottingham after 1960s slum clearance forced them to find alternative employment and housing. Long Eaton blossomed around the railway and lace-making industries in the nineteenth century. Its Silver Prize Brass Band was formed in 1906, and in 2006, won the Midland Area Regional Championships.

Tamworth Road, Long Eaton, 2008. Today, the former Post Office premises are up 'To Let'. As recently as the 1980s, policeman wearing capes and riding bicycles could be seen patrolling the market area just opposite where this shot was taken. I am always fascinated by the 'New Inn' pub just past the railings on the left, as plates of tasty sandwiches can always be seen through the frosted glass window of the pub kitchen.

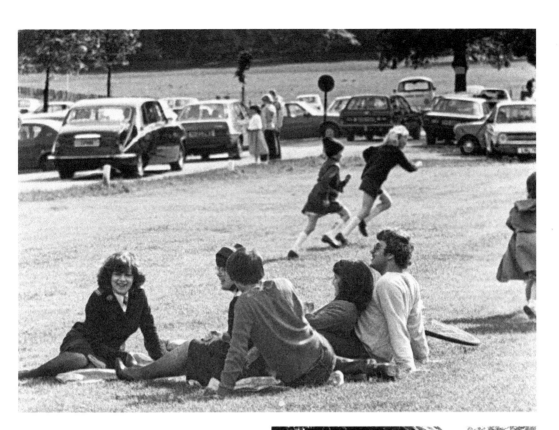

Wollaton Park, Nottingham, 1981. In the 1980s, the park often held events such as Salvation Army parades, archery competitions, and dog handling shows. Between 1945 and 1947, German prisoners of war were held in compounds at Wollaton Park, and wore uniforms with a large 'P' printed on the back, to signify 'Prisoner'. Members of the U.S. 508th Parachute Regiment also stayed here during the war.

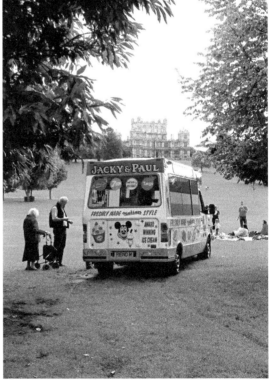

Wollaton Hall and Park, 2008. The Hall, seen in the background, was built in 1588, for Sir Francis Willoughby (1547-1596), by Robert Smythson. Several paintings by the artist Verrio hang inside, and the Hall also contains an ancient pipe organ, as well as the Natural History Collection. The park is famous for its free-roaming deer, large lake, and Camellia House, the oldest cast-iron building in Britain. The ice-lolly is known locally as a 'sucker', and provides much-needed refreshment after a walk round the lake.

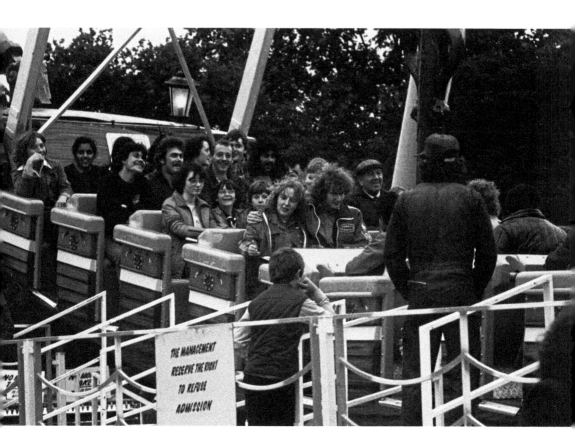

Nottingham Goose Fair, Forest Recreation Ground, 1981. Customers are enjoying a ride on
Pat Collin's Pirate Ship. In 1284, King Edward I proposed a charter that a 'fair will be held in
Nottingham once a year'. The opening ceremony is traditionally held at noon on the first day, with
Nottingham's Lord Mayor ringing a pair of silver bells. This is followed by the Town Clerk reading
the Proclamation, witnessed by the Sheriff of Nottingham. The Fair was initially held in the Old
Market Square, but in 1928 it had got so vast that it had to be moved to The Forest Recreation
Ground, just off Gregory Boulevard. It is said to be named after the custom of farmers driving geese
from Lincolnshire, to be sold in Nottingham. The Goose Fair was cancelled when the Bubonic Plague
struck in 1646, and also during WW1 and WW2, as the glaring light displays would have attracted
enemy planes. Traditionally held during the first week of October, the Fair is a place to bump into old
school friends, not seen for several decades, soak up the atmosphere, and generally have a good time.
Goose Fair week is normally plagued with showers and grey skies, giving rise to the Nottingham
saying 'Goose Fair Weather'. Stallholders have now taken to laying duck-boards over the grassed
areas to prevent customers sinking into the mud pounded by thousands of local feet.

The mouth-watering smell of fried onions and hot peas is always guaranteed to take me right back
to my childhood, and sometimes the meat option of a burger or hot-dog is often disregarded with the
simple request for an fried onion 'cob', (Nottingham slang for a bread roll or bap).

Forest Recreation Ground, 2008. Neatly marked into bays, the Goose Fair site is now, for most of the year, the Park and Ride site for the Nottingham Tram. In the Middle Ages, this area was an open meadow named 'Whistondale', due to its proximity to the area known as Whiston. The race course on the 67-acre Forest was laid out in the 17th century, and the impressive grandstand was built in 1777, by the York architect John Carr, at a cost of £2,400. Racing continued until 1890, when the course was closed. An 1801 map shows ten windmills in existence on the southern boundary of the Forest. Eighty years ago, tanks and guns from the Great War stood here, until they were broken down for scrap in 1930. The labourers started to cut through the metal with oxy-acetylene equipment, oblivious to the fact that the tanks were still full of petrol! In 1999, a rare flower, meadow saxifrage, dating back to the Ice Age, was found growing on the Forest. More recently, as well as the Goose Fair, this site has also hosted many Rock and Reggae weekends, several circuses, and the Hyson Green Festival.

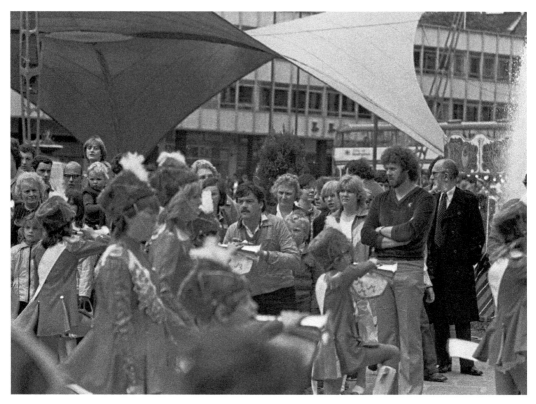

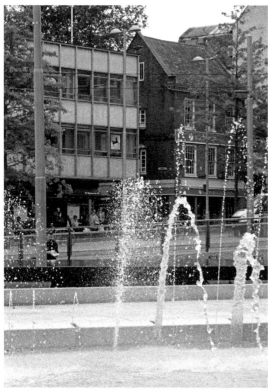

Marching band, Old Market Square, Nottingham, 1982. In the background are the headquarters of Lloyds Bank and a traditional Nottingham green and cream bus. One of the Square's original water fountains can be sent on the extreme right of the photograph.

Fountains, Old Market Square, 2008. The recently revamped Square was officially opened by HRH The Princess Royal on Tuesday 3rd April 2007. Costing £7m, the old 'Slab Square' has been completely transformed, with granite flagstones, flowerbeds, public seating areas, and the attractive water features shown here. Far from the pigeon-infested haven it was twenty years ago, the new square now hosts many Farmers and Continental Markets, selling a range of goods from ostrich-burgers to smoked German sausages and Christmas gifts.

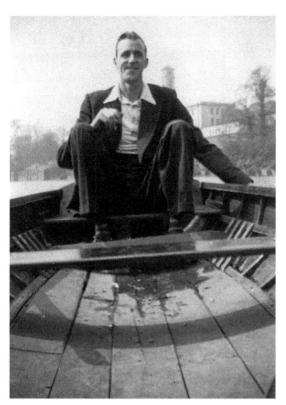

Harry Richards, Nottingham University Boating Lake, Beeston, 1953. Behind my father, in the background, stands the tower of the famous Trent Building, erected in 1928 when University College Nottingham first moved to this location. In November of that year, King George V officially opened the site. The University has attracted some famous visitors over the years, including Albert Einstein, H. G. Wells, and Mahatma Gandhi. There are a total of twelve Student Halls of Residence currently within this campus.

Nottingham University Boating Lake, 2008. Over fifty years later, the clock-tower and boating facilities are still here, and the lake is now popular with students and joggers. The excellent Aqua restaurant is situated next to the lake, within the D. H. Lawrence Pavilion, which hosts many film shows and art exhibitions.

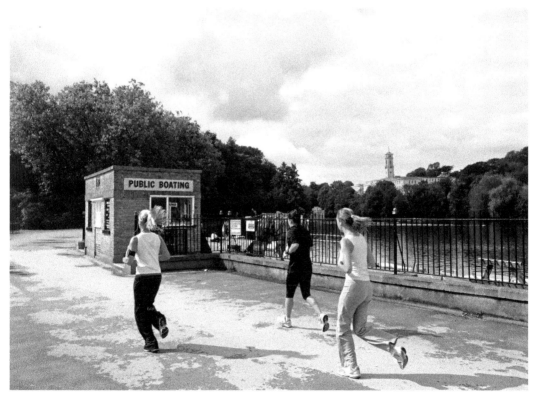

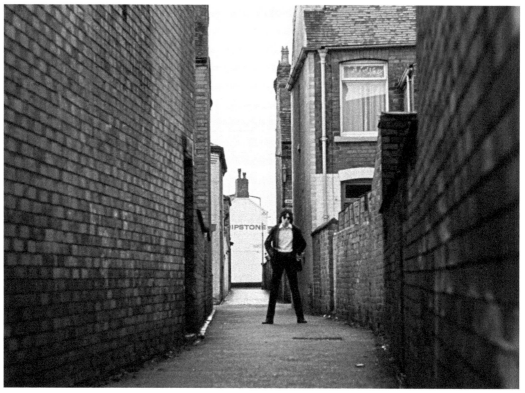

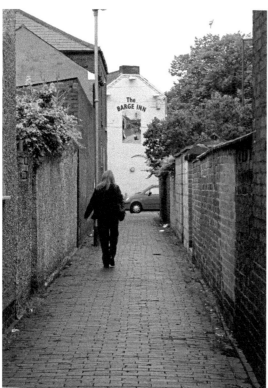

Chris Richards, Long Eaton, 1982. The author is standing in an alleyway or 'twitchell' as it known locally, connecting the Victorian terraces of Friar Street and Nelson Street. The pub in the distance was at this time called 'The Lord Nelson', the beer being provided by Shipstones Brewery of Basford. Later it became 'The Old Ale House'. Over my left shoulder is the ever-present camera bag, containing spare lenses, and rolls of Ilford film, all of which could now be contained within a digital camera the size of a packet of cigarettes.

The Barge Inn, Tamworth Road, Long Eaton, 2008. Twenty-six years later, weeds and foliage seem to be taking over. This pub was probably renamed due to the proximity of the local canal, which is visible whilst enjoying a pint of beer at this popular alehouse. The venue also hosts local rock and blues bands on certain nights of the week.

Party at Kennington Road, Radford, 1957. Here Shirley Pearson (left) and friends enjoy a house party. Families often gathered after the pubs closed for a sing-a-long round the piano, often accompanied by a sandwich and pickled onion supper. At this time, Kennington Road was mainly residential, being close to Raleigh Industries and Player's cigarette factory. Shops located on the road at this time would have included Bannister's hairdressers, Harris's and Olive Smith's grocers shops.

Kennington Road, Radford, 2008. In the 1970s, part of this street was demolished to build a new school, which resulted in the destruction of some of the local allotments. Some of the original housing still remains, situated opposite the Players Bonded Tobacco Warehouses on Wollaton Road. When I was at school, this road was known simply as 'Kenno'.

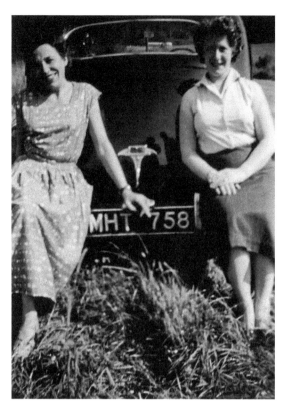

Girls at the Hemlock Stone, Bramcote, 1957. Here, Lisa Richards (left) and Brenda Brocklebank (right) enjoy a day out in 'Marilyn', my fathers' Mark One Triumph Standard Vanguard, named after the famous female film star of the time. Looking at the shadows in the polished car bodywork, I would assume that the photographer is Brenda's husband Paul.

The Hemlock Stone, 2008. This sandstone mass is believed to have been formed during the Triassic Period millions of years ago. The upper black section of the stone is impregnated with barytes, giving it the distinctive dark colour. It is unsure whether the stone has been shaped by man, or by natural forces, There is also a 'Hemlock Stone' pub, some distance away at Wollaton.

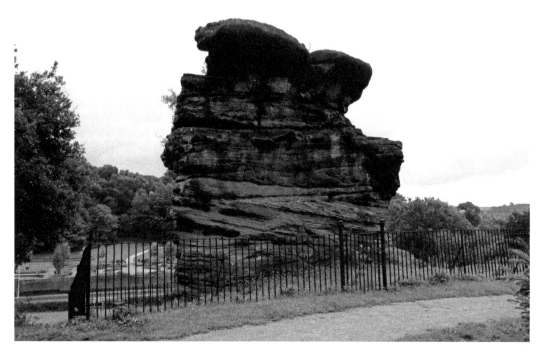

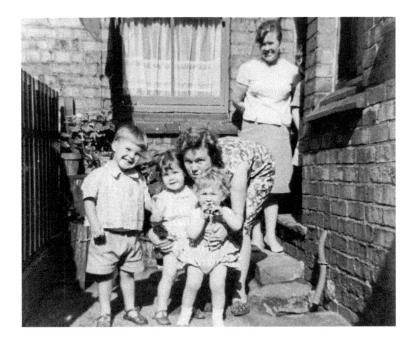

Brand Street, Nottingham, 1963. Seen here are Evelyn Bedford (standing) and sister Sheila Brewitt with children Gary, Christine and Helen. Brand Street was located just off Meadow Lane. Many children of the 1960's generation will own a similar picture.

Brand Street area, 2008. The house probably stood to the left, where new units have been built.

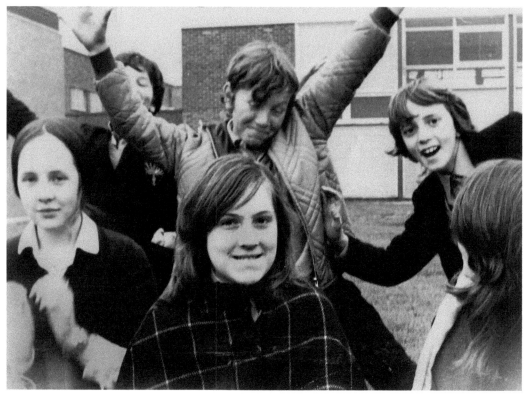

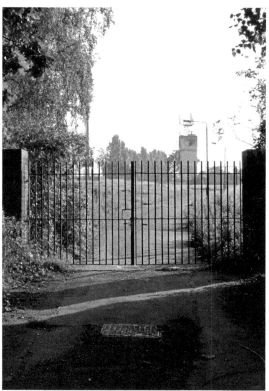

Padstow School, Bestwood, Nottingham, 1972. Deborah Neagle (centre) and friends are fooling around with a camera during a photography lesson. In the days when teachers wore flares, 1970s comprehensive schools in Nottingham were scary places, with the constant threat of 'having your head stuck down the toilet', or a piece of timber slapped about the head in woodwork class. Icy playgrounds would be transformed into 'slides', with pupils taking turns to skid along one section again and again, transforming it into a sheet of glass which was lethal to walk across, especially for schoolmasters on break duty who happened to lose their footing.

Padstow School Gates, 2008. Now the path leads to nowhere, although the line of poplar trees further up marks the spot where the school stood.

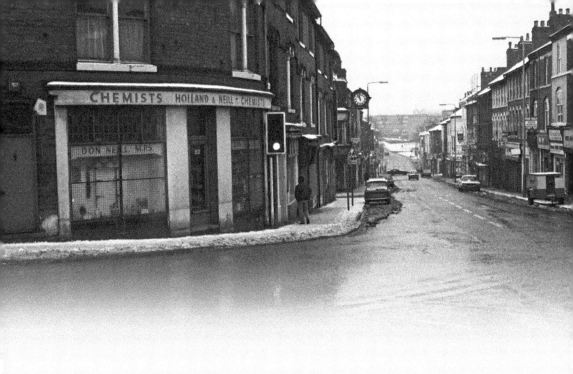

chapter 2

Shopping and Retail

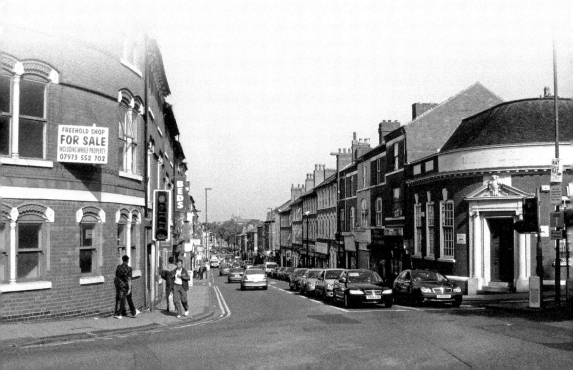

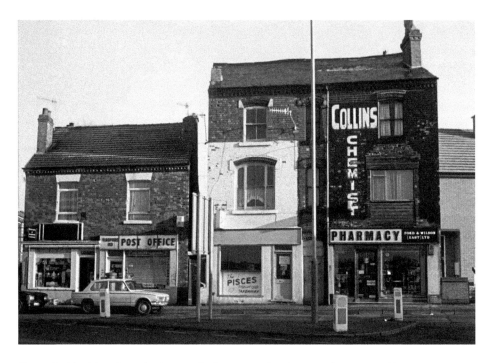

Shops, Radford Road, Basford, 1985. In the 1930s, the chemists shop was William Lunn's drapers and the Post Office at that time belonged to George Frederick Leivers. Pisces chippy was formerly the Telephone Call Office, well before the modern age of mobile phones.

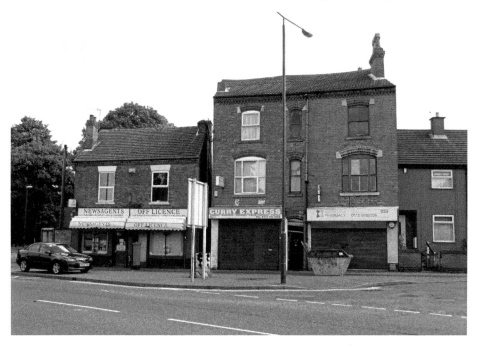

Shops, Radford Road, Basford, 2008. Edward Collins took over the chemists shop at some point in the 1950s. Although the shops on each side have retained their original purpose, the chip shop in the middle has been converted to an Indian Takeaway.

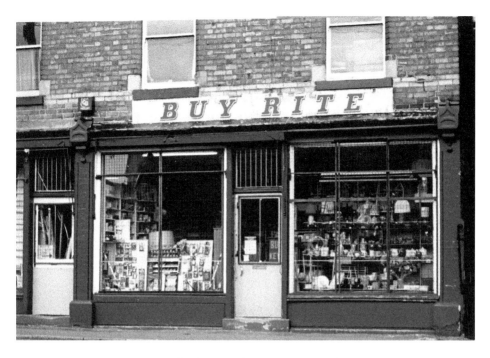

'Buyrite' shop, Lincoln Street, Basford, 1986. There were several of these 'bric-a-brac' shops located here in the 1980s, which all seemed to sell secondhand records and old books. However, this one appears to be some sort of hardware emporium.

Lincoln Street, 2008. This building is now being converted into housing, ideal for getting into the City Centre via the nearby Basford tram stop. With its old identity removed, yet another quirky shop has been driven away in a builder's skip.

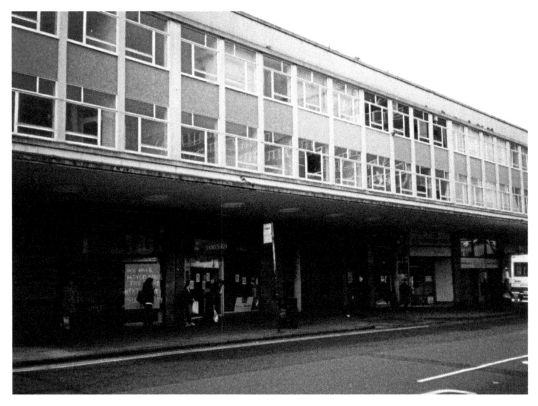

Trinity Square, Nottingham, 1997. These 1960's shops were constructed to replace older establishments such as Will Hill's tailors, The 'Dog & Gun' public house, Ward's car dealers and Cliffe's hairdressers. A 1950's advertisement for Trinity Square offers 'exclusive tailoring by Bob Patchett Ltd'. By the time this photograph was taken, the buildings were already showing signs of wear and tear, although the overhanging design of the offices above did offer protection from rain while waiting for a bus.

Trinity Square, 2008. In the centre, we see the former 'Works' nightclub, which closed a few years ago. Next to it was the popular 'Sausage Bar' located on the corner. However, this recently closed and the plot has been taken over by Strada, an Italian restaurant. Nottingham's Forman Street area is now a haven for workers enjoying a meal or drink after finishing work, chatting and eating 'al fresco' from tables on the street itself.

Bracebridge Co-op store, Bracebridge Drive, Bilborough, Nottingham, 1987. The Co-op was open here as early as the 1950's, as were neighbouring shops Boots The Chemists, Dewhursts Butchers and the City of Nottingham Welfare Centre. Arthur Bambury also had a fish and chip shop on this road. Bilborough's famous 'tin houses' were put up quickly to solve the post-war housing crisis, but most are still standing today. The awful taste of the gum on the blue Co-op Dividend or 'Divi' stamps will probably never leave my memory, when as a child I pasted them into blue books to receive discount on future purchases.

Bracebridge Co-op, 2008. A far cry from the small shops opened by the Rochdale Pioneers in the 1840's, the modern day Co-op store is fresh and innovative. As schoolchildren, we often purchased French bread from this Co-op, hollowed out the middle, and got the shop up the road to fill it up with chips.

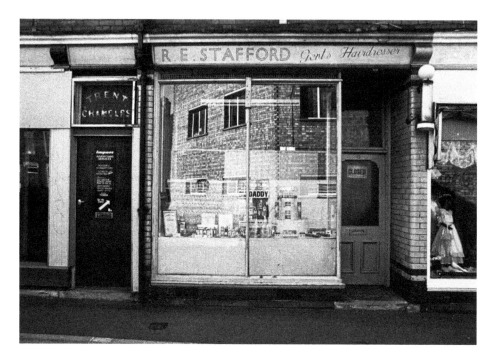

Stafford's Hairdressers, Gibb Street, Long Eaton, 1988. Ray Stafford, the proprietor, was a stalwart of Trinity Methodist Church. I can almost feel the super-sharp 'scrape' of the open razor on the back of my neck, when I think about these old-school barber's shops.

Gibb Street. 2008. Expecting to see the area demolished, I returned exactly twenty years later to take this shot. The Long Eaton area has not seen the redevelopment that has transformed Nottingham, and some of its streets are still quite quaint.

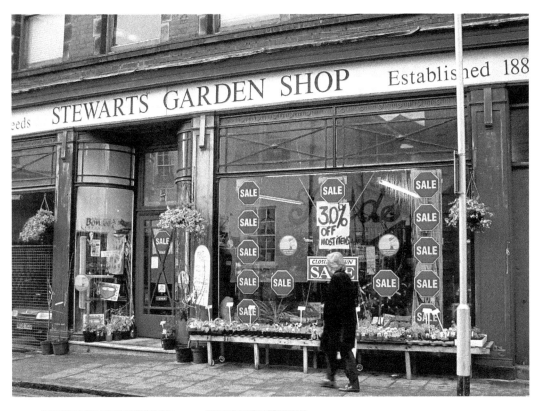

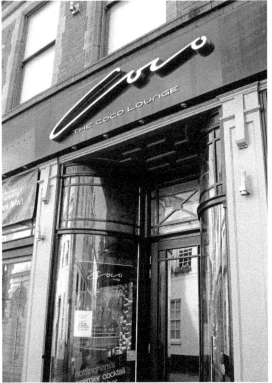

Stewarts Seed Shop, George Street, Nottingham, 2001. This shop was formerly The Corporation Gas Department and Woodhouse's builders merchants. As far back as the 1930s, a variety of shops could be found here, including Harold May's leaded light manufacturers, The Nottingham Patent Brick Company and Percy Sweet's printers. Stewart's was formerly located on Market Street, next to the Scala Cinema.

The Coco Lounge, George Street, 2008. The old shop has been closed down and lives on as a popular night-spot for Nottingham's younger generation. Famous for its selection of cocktails, this building still retains its fantastic curved glass entrance, an architectural feature shared with the old 'Crystal Palace' pub on Clumber Street, which is now an amusement arcade.

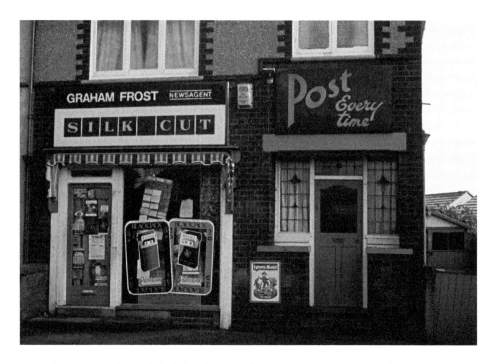

Frost's Newsagents shop, Nuthall Road, Nottingham, 1985. Formerly Edward Gough's tobacconists, this shop had amongst its 1930s neighbours, Marlow Baptist Church, The British Oxygen Company, and Gott's boot and shoe dealers.

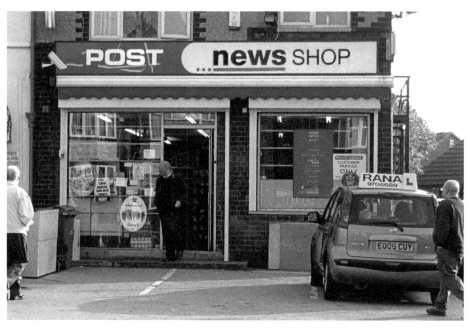

Nuthall Road, 2008. Thirty years ago, we would walk from Glaisdale School to this shop, and buy the popular confectionary 'Space Dust', which we would then empty into our mouths and mix with cans of Coca Cola. Another silly schoolboy trick was to see who could eat the most Jacob's Cream Crackers in one go, without choking!

View down Radford Road, Hyson Green, 1985. The large clock in the centre of the picture belongs to Staddon & Sons home furnishers shop. Staddons also kept several other shops along this street in the 1940s, including a gents outfitters, a drapers, and a hosiers. The Hyson Green flats complex can be seen in the distance (also see page 39).

Radford Road, 2008. Drastic restructuring of the chemist's shop, and much more traffic!

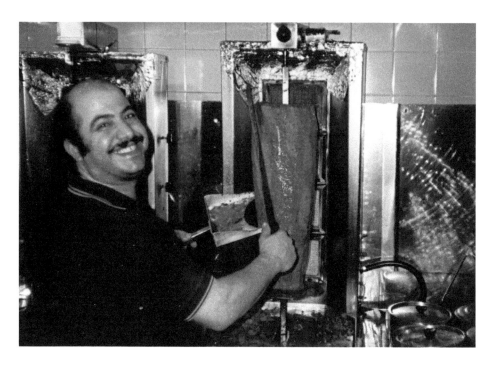

George's Kebab House, Beechdale Road, Bilborough, 1988. George, the owner, was always smiling and friendly, as seen here, and his white Mercedes was always parked outside the shop. I would often catch the number 56 or 60 bus to town outside this shop in the 1970s.

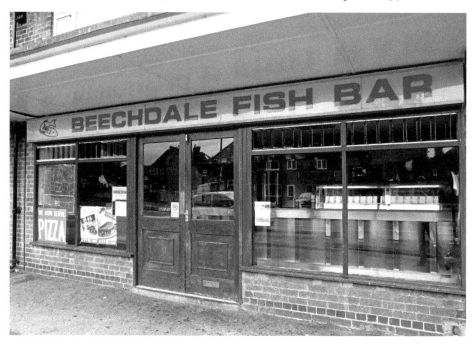

Beechdale Fish Bar, 2008. The sign in the window states 'Great night, great kebab, take me home!' I sampled my first donor kebab at Antalyas in Nottingham in the late 1970s, and was foolish enough to squirt some 'tomato' sauce all over it from the bottle on the counter!

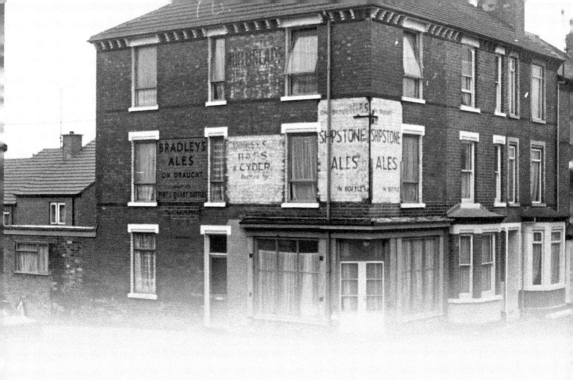

chapter 3

Housing

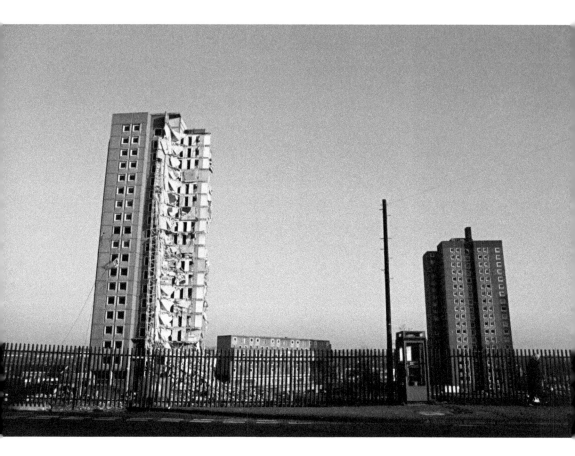

Demolition of Basford Flats, Stockhill Lane, Basford, Nottingham, 1985. These flats were built
in 1967, and took four years to complete. However, they were constructed quickly from pre-cast
concrete panels, and soon suffered from problems including damp, condensation and also proved
impossible to heat. The low-rise blocks (as seen in the centre of the picture) included Jura, Eaglesham,
Ferryden, Glengary, Calgary, Bannock, Allenby, Kinlock, Quarrymore and Morven. The high-rise
blocks were Evans Court, Wicklow Court, Auburn Court and Mill Court. I often visited a friend
at Auburn Court in the 1970s, who would throw banana skins, teabags and apple cores out onto
the street from a tenth-storey window! There were also stories of the wrong item, such as uncooked
joints of meat, being thrown down communal rubbish chutes by mistake. Although several of
Nottingham's high rise flats have survived, such as Woodlands at Radford, and the Lenton Flats
complex, others like such as these and the Balloon Woods complex were demolished barely a decade
after the paint had dried on the walls.

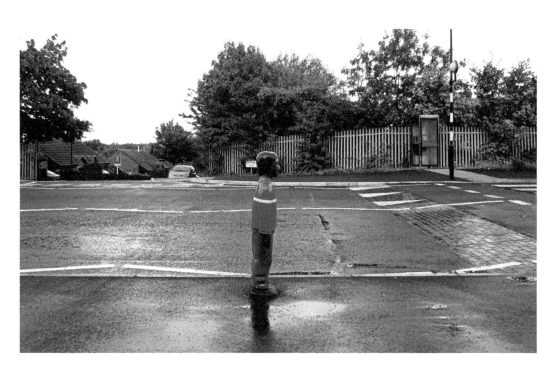

Stockhill Lane, 2008. Today, the phonebox and the railings remain, but a new estate has been built in place of the old flats. With a horticultural theme, the new streets have been named Coriander Close, Clover Green, Violet Close and Bramble Close. The old 'Horse & Jockey' pub remains from the original clearance programme, situated on David Lane. The child figures have been erected by the Council as a traffic calming measure near schools, but often they are either snapped off or sprayed with paint. A 1901 map of the area shows an array of small streets such as: David Square, Queen Square, Alice Square, and Brown's Croft, and a small manor house standing to the left of the site. The Nottingham & Mansfield Railway passed through Basford Station at this time, in between an iron works and a corn mill.

Boarding house, Maples Street, Hyson Green, 1985. George Dixon's beer retailer on the corner has had its windows draped with net curtains, and no longer serves the 'pint and quart bottles' stencilled onto its ancient brickwork in post-war paint.

Maples Street, 2008. Today the former off-licence has had its corner bricked up and undertaken the inevitable conversion into housing. The ancient beer advertisements or 'ghost signs' have been erased by sandblasting, in an attempt to restore the exterior to its original condition.

Demolition of Hyson Green Flats, Radford Road, Nottingham, 1987. This 1960's deck-access flats complex consisted of 593 flats, built on land formerly occupied by Archer Street, Cornhill Street, Bedford Square and Saville Street. The majority of the tenants were on state benefits, and a large proportion were single parents. The flats soon became a haven for crime, and were condemned in 1984, being demolished three years later. Several occupants remained in the flats right till the end, hosting 'blues' parties with electricity diverted from the street lighting, and planks placed across the broken sections of concrete deck to gain access.

Radford Road, Hyson Green, 2008. Now the space where the flats once stood is occupied by an ASDA superstore, and lush tree growth replaces the broken concrete of the former picture

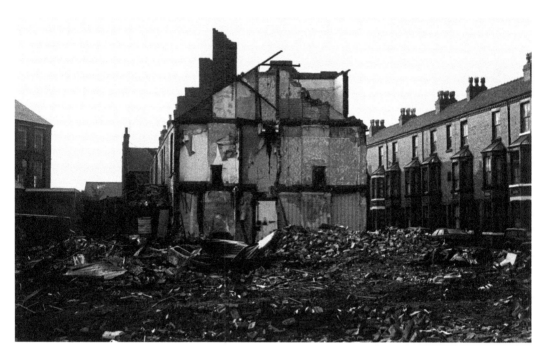

Demolition of Alderney Street, Castle Boulevard, 1982. The Steada Raywarp factory is visible on the far left of this shot. During my early morning photo-sessions, this industrial area seemed to be full of workers clutching sandwich packs hurrying to work for the morning shift.

Alderney Street, 2008. Although the right-hand side of the street seems unchanged, the left-hand side has been redeveloped as the Castle Gardens complex, a mere ten minutes walk from the City Centre and Nottingham train station.

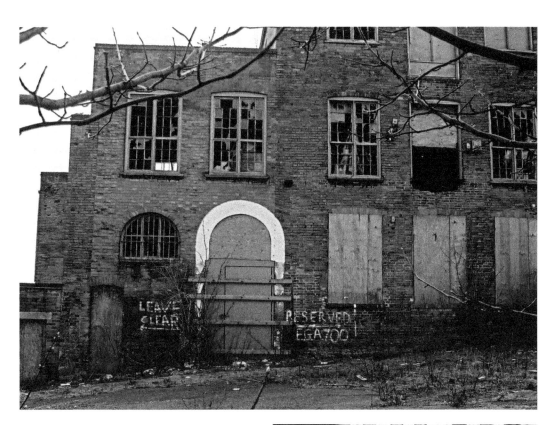

Altons Cigar Factory, Ilkeston Road, Radford, Nottingham, 1984. I can assume that 'Reserved for EGA 700' is the parking space for the owner's car. This factory, built on the site of Elliott Street, Park Hill and Hermon Street, was sandwiched between Robson's chemists shop and Jack Sholl's butchers, formerly a coal merchants. This area, known as Canning Circus, has several interesting pubs within its vicinity, including the Falcon and The Sir Borlace Warren.

'The Cigar Factory' flats, 2008. Thankfully, the old listed building on the other side has been retained, and new sections added on top. The popular music venue 'Junktion 7' is located on the other side of the road, and in a few years ago, before their rise to fame, Sheffield band Arctic Monkeys played here.

Wallan Street, Radford, 1982. Looking past the Ford Cortina, we see a cleared expanse of land across Alfreton Road which used to contain the terraced houses of Oldknow Street, Brown Street, and Carlingford Terrace. Many corner shops in this area were beer retailers, such as Horace Walker, Lily Osborne and Percy Harris. An old lady in a corner shop just round the corner once greeted me with the phrase 'Steal those sweets and my dog will get you!'. The cleared land in the foreground was formerly housing on Osborne Terrace.

Wallan Street, 2008. The former 'Shipstones' off-licence on Ben Street belonging to Mrs Emma Burton has now been converted into housing, and overhanging branches of a childrens' playground now frame the shot.

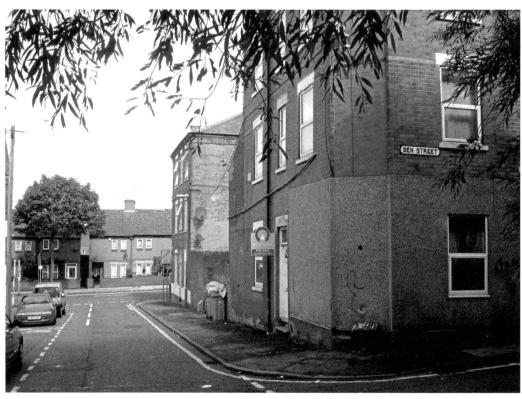

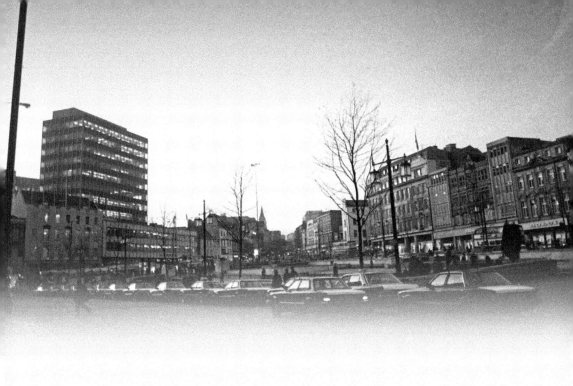

chapter 4

Transport

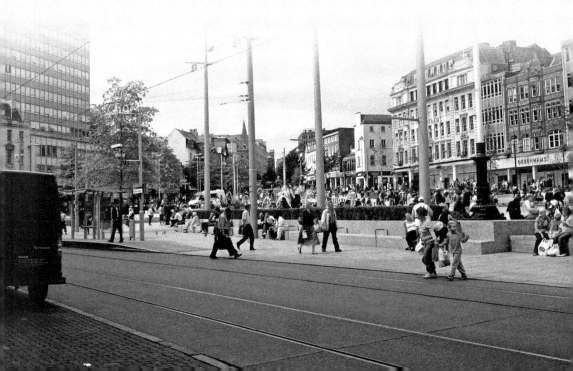

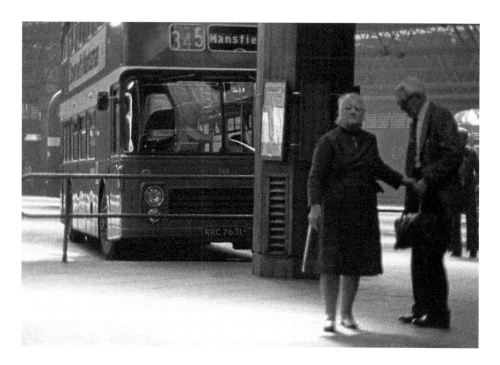

Victoria Bus Station, Nottingham, 1982. Here, the 345 for Mansfield is about to leave the station. My memories of this station are of a smoky, dirty and uncomfortable place, with a small coffee bar which seemed to sell little more than weak tea and warm sausage rolls.

Victoria Bus Station, York Street, Nottingham, 2008. Looking like an illuminated Toblerone, the new station is considerably smaller than the vacuous 'aircraft hanger' shown in the previous shot, but still serves the population of Nottingham well.

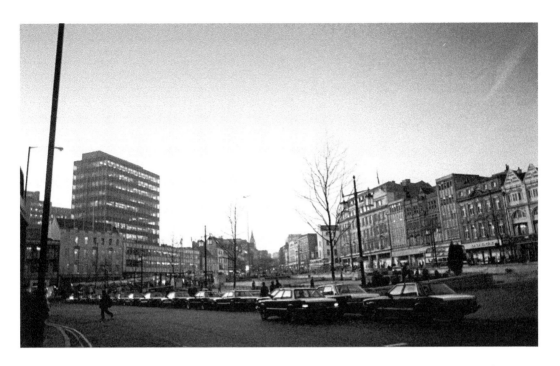

Taxi rank, Old Market Square, Nottingham, 1984. I once took a cab to the train station early one morning, as a student, and was surprised to see the girl behind the reception prodding and shouting at a blanket on the floor, from which my driver emerged!

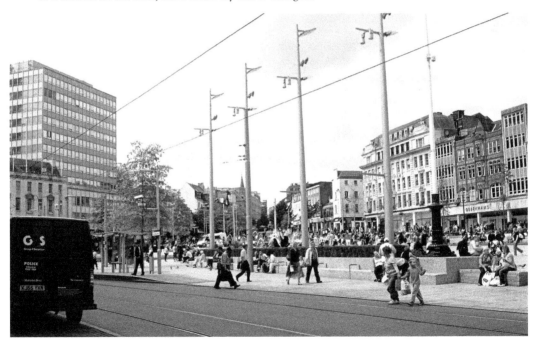

Old Market Square, 2008. The famous 'black and white' cab parking bay is just a memory, and has been replaced by tramlines. Nottingham Express Transit's first line opened to the public on 9th March 2004, after an investment of £200 million.

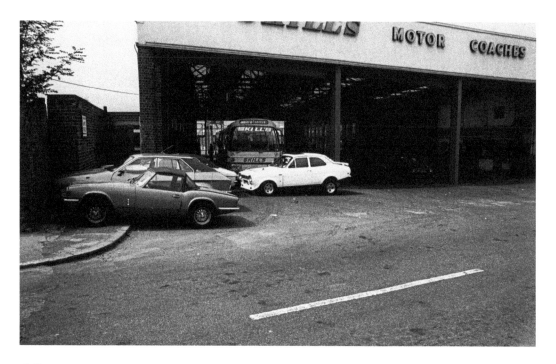

Skill's Bus Depot. St. Peter's Street, Radford, 1982. This business was established in 1919 by Arthur Skill. Sharp-eyed car enthusiasts will have spotted a Triumph Spitfire, Austin Princess, Ford Cortina, and a highly modified Ford Escort. An old Citroen also lurks inside the garage.

St. Peter's Street, Radford, 2008. New student flats have been built on the cleared Skills site, by the banks of the River Leen. Just out of shot, on the left, is the 'Plough' public house, which has its own excellent micro-brewery built into the rear of the premises.

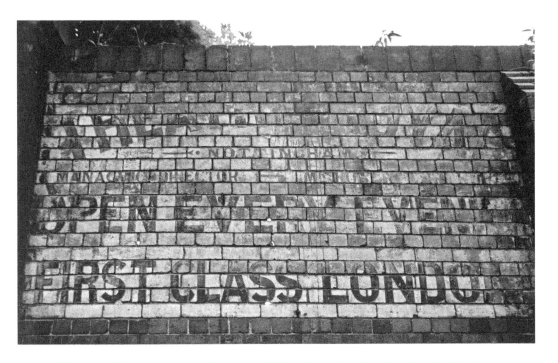

Old Sign, Weekday Cross, Nottingham, 1984. This ancient sign painted on blue-black brick, advertises Nottingham's Theatre Royal. Just over the wall was the footway known as Garners Hill, an ancient assemblage of steps and cobbles, treacherous in icy weather.

Weekday Cross, 2008. Now both the sign and the viaduct are gone, and work is well under way on the new £13 million Nottingham Centre For Visual & Live Art. It is proposed that the Centre will bring together studio and exhibition space, a learning centre and a café, all under one roof.

Alfreton Road, Nottingham, 1985. The Viking Engineering factory is in the background, with its 'sawtooth-shaped' roof sections typical of industrial buildings of this period. The car is an 1969 Austin Maxi in semi-roadworthy condition.

Alfreton Road, 2008. In a very poor state of repair, the old factory has had its chimney removed and most of its windows smashed. Opposite this factory is Poulter Close, which follows the course of the River Leen right through to St. Peter's Street in Radford.

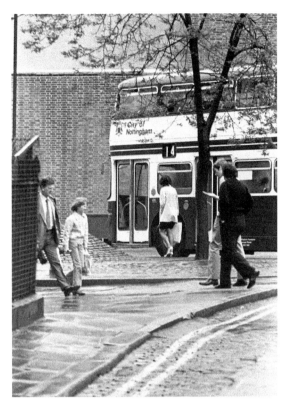

Fletcher Gate, Nottingham, 1981. Taken from the top of Bottle Lane, this shot shows the number 14 bus travelling from West Bridgford via the Meadows to South Parade. Fletcher Gate is said to have been named after the butchers shops or 'flesh-hewers' which were popular here many years ago. Other 'Gates' are situated in this area, including Barker Gate, Pilcher Gate and Warser Gate.

Fletcher Gate, 2008. Although the cobbles of Bottle Lane have been retained, massive redevelopment has taken place, with new apartments, a Coffee Republic Shop and the Lace Market tram stop being situated here. Further along Bottle Lane there was a pub named the 'Queen Elizabeth' which was demolished a couple of years ago to allow an extension to the Ibis hotel.

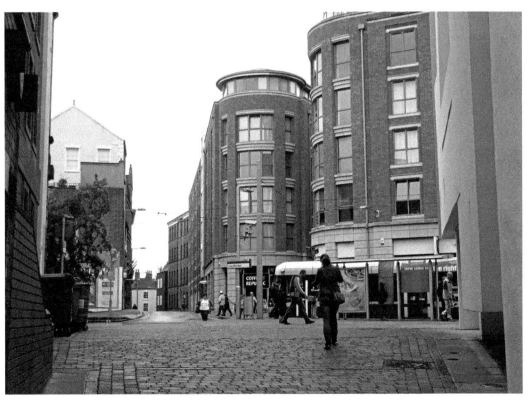

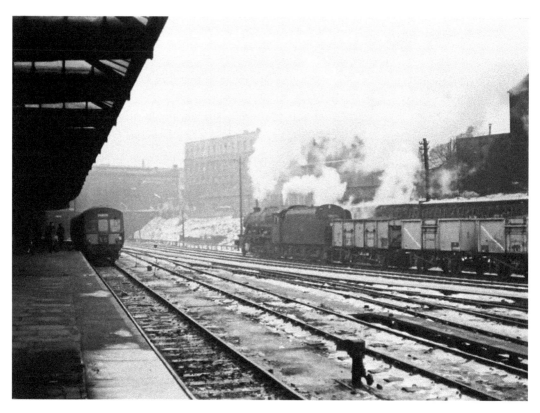

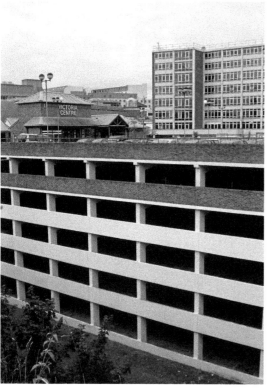

Trains at Victoria Station, Nottingham, 1961. Victoria Station was demolished in 1969, and now only the clock tower and adjoining hotel (built in 1901) remain. Rubble from the station was used as hardcore under modern housing estates such as Rise Park, along with bricks from the destruction of the St. Ann's area around the same time. Another local station, Nottingham Midland, was spared the bulldozer, and lives on today as Nottingham's main railway link with the rest of the country.

Victoria Station site, 2008. After laying dormant as a 'hole in the ground' for forty years, this area now functions as the Victoria Centre car park. The Centre was completed in 1972, and has two floors of retail outlets, plus an indoor market, with a wide variety of shops including a West Indian food takeaway, several cafés and a Hot Pea stall, complete with strategically placed bowls of mint sauce.

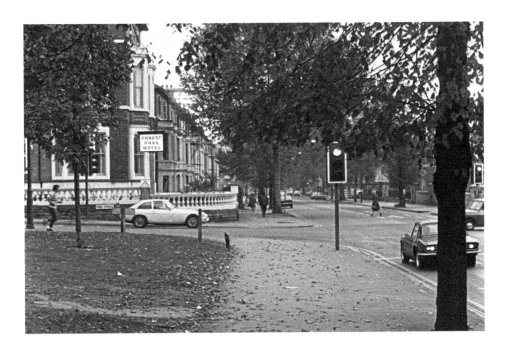

Gregory Boulevard, Nottingham, 1982. This photograph shows the junction with Noel Street. This boulevard, along with Western Boulevard, Castle Boulevard, and Radford and Lenton Boulevard, are the main arterial routes around the City Centre. Three-storey properties such as the spacious ones on the left are ideal for students or large families.

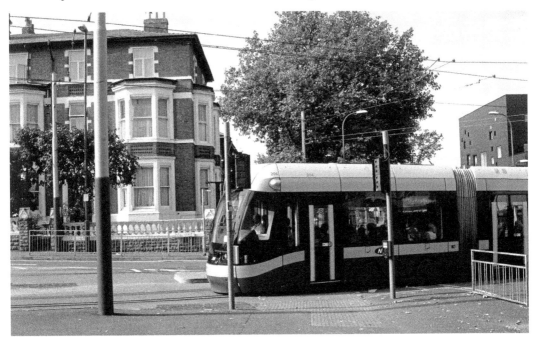

Gregory Boulevard, 2008. The Forest Park Hotel has now closed, and is now student accommodation. Twenty six years later, autumn leaves are starting to litter the pavements as the local tram speeds its way to its Station Street terminus.

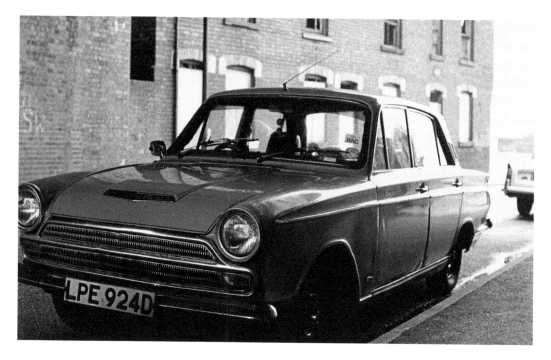

Hungerton Street, Castle Boulevard, 1981. This Ford Cortina is parked under Abbey Bridge, in the area known as New Lenton, in front of a Triumph Vitesse. 31, 33 and 35 Hungerton Street are in background, boarded up, and awaiting the demolition crews.

Hungerton Street, 2008. Garages have been built on the site of the cleared properties, and new houses on Petersham Mews can be seen in the distance. As children, we called this underpass 'Scary Bridge' and ran through it as quickly as possible.

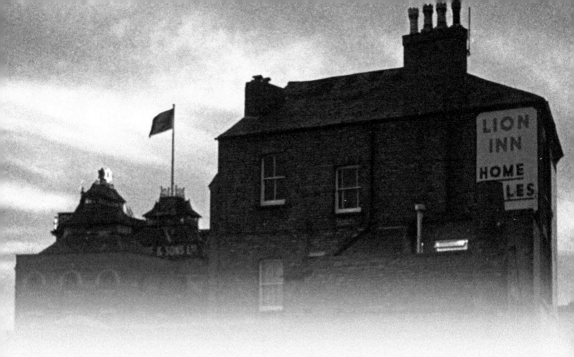

chapter 5

Pubs

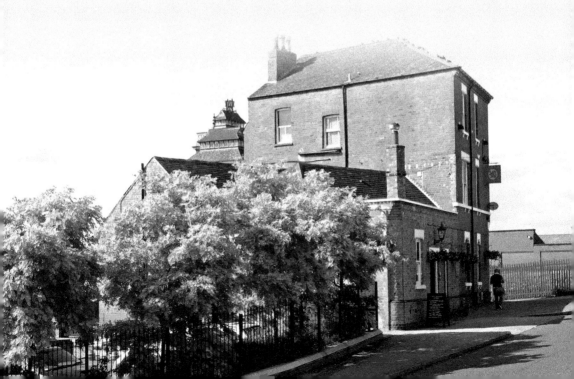

The 'Pheasant Inn' on Prospect Street, Radford, 1925. This photograph shows William King, the landlord. The pub was later tenanted by ex-professional footballer Jack Waterall for many years. Around the time this picture was taken, Prospect Street had many small terraces branching off it, including Lydia Cottages, Seaham Place, Weston Cottages and Rose Hill Cottages. The Bridgford Cabinet Manufacturing Company was also located on this street.

The 'Pheasant Inn', 2008. Although tucked away in a quiet inner-city street, this building has something of a 'country pub' feel about it. The 'Pheasant' was the winner of the Best Community Pub Award 2006–2007.

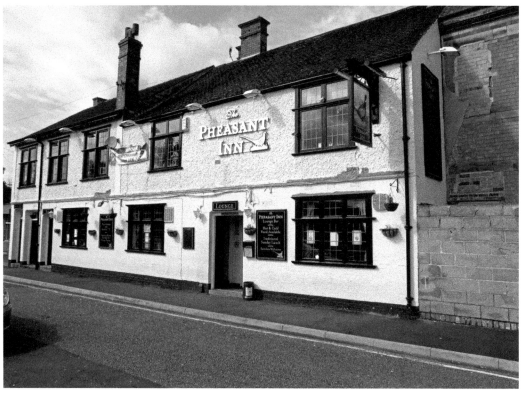

'Sir Garnet Wolseley Pub', Denman St Norton St junction, 1956. The gentleman is 'Lance' Wright, the owner of the pub, pictured with his dog, Ace. Lance took over from George Fisher, who was the licensee in the 1930s. The young boy is Billy Morley, who lived at 6 St. John's Terrace, Radford, before emigrating to the United States in 1953. In the background, beer barrels are being unloaded from a Shipstones wagon. The Denman Street area was a thriving shopping area in the 1950s, with at least four chip shops, a wireless shop, foot clinic, piano tuner, a lending library and many more too numerous to mention. This photo was taken on a return visit to England by Brenda Morley.

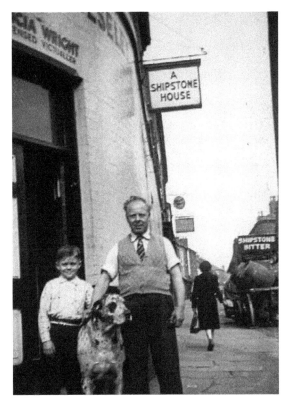

Denman Street, Radford, 2008. This pub replaced the original 'Sir Garnet Wolseley', and was renamed 'The Globe' at some point in the 1990s, before falling derelict. In the background is low-level housing which has replaced the Denman Gardens complex.

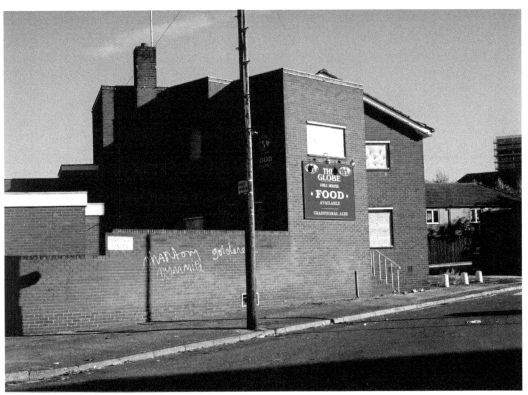

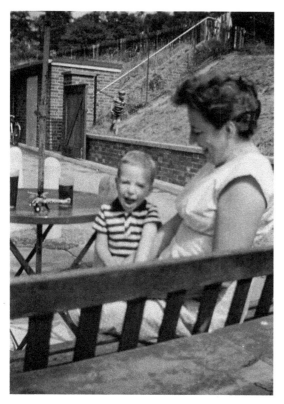

Chris and Lisa Richards at the 'Priory' pub, Lenton Abbey, 1964. In the background of this shot, we see a fenced-off area known as Thompson's Wood, adjoining Wollaton Park. I can remember very little about my childhood visits to local pubs, but I do recall the bottles of 'Apollo' pop, with their varied flavours such as cherry, cream soda, orange, lime and pineapple. These were carefree days, and I have been told I was often asleep in the back of the car when we got home, without having touched a single drop of alcoholic drink.

Former 'Priory' pub, 2008. The woodland to the rear of the building has now been cleared and replaced by an Innkeeper's Lodge motel complex, cleverly placed to gain custom from the nearby University of Nottingham. Today, large pub chains such as these tend to fare rather better than the small pubs, many of which are losing custom.

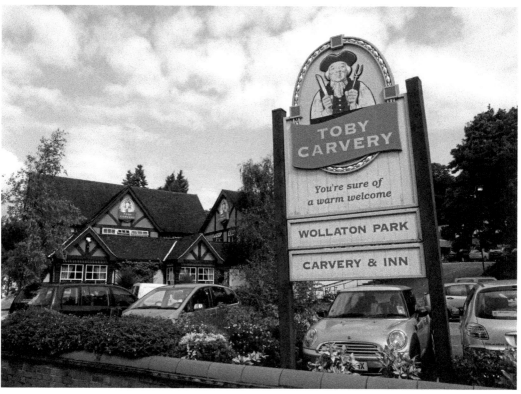

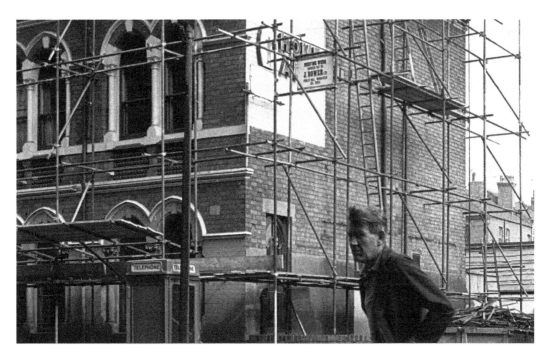

'The Boulevard Hotel', Radford Boulevard, 1981. This hotel dates back to 1883, and was supplied by Home Ales when this photograph was taken. Note the pedestrian's digital watch, the ultimate 1970's fashion accessory.

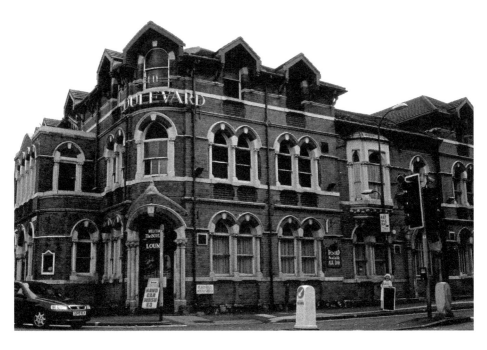

'The Boulevard Hotel', 2008. Now closed, this pub now offers a Hand Car Wash for £3 in the car park at the rear of the pub. Often, this is the only use for these buildings, as a recent Government survey has revealed that over thirty pubs a week are closing in Britain.

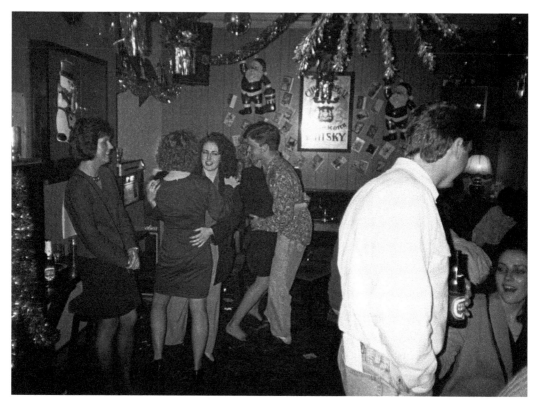

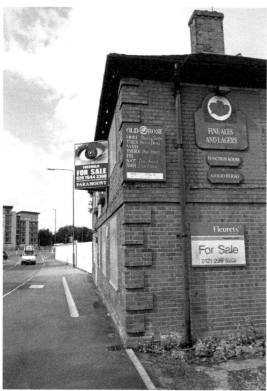

The 'Old Rose', St. Peter's Street, Radford, Christmas 1988. Here, customers enjoy a festive disco in the lounge area. The area once boasted a lively social schedule of darts and pool matches with most of the other local pubs, including The Midland, The Jolly Higglers, The White Horse, The Plough and The Crown. The 'Midland' was where I first sampled Bovril-flavoured crisps as a youth.

St. Peter's Street, 2008. The pub has now been closed for several years, and in the distance we can see the former site of GT Cars, and Radford Weighbridge, fenced off, ready for redevelopment. The newly built Raleigh Park apartments are in the distance (also see page 74), and mislaid Christmas lights can still be seen, high up at roof level.

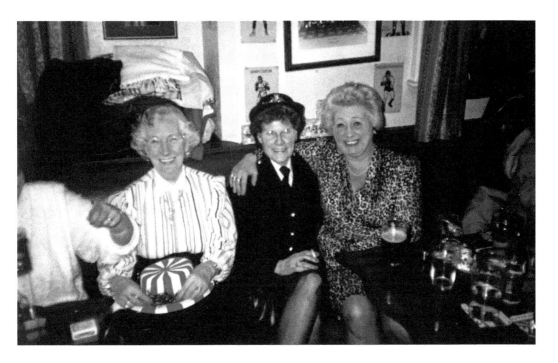

New Year's Eve celebrations at the 'White Horse' pub, Radford, 1989/90. The postcards on the wall reflect the pub's connection with the local Boxing Club, situated in the outbuilding at the rear. Consequently, 'trouble' at this pub was a rare occurance.

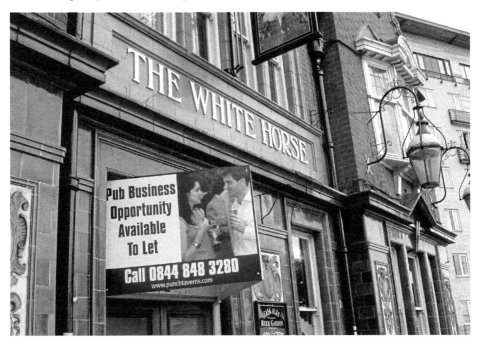

The 'White Horse', 2008. Most of the local pubs now display a sign such as this, some are boarded up but others remain open with limited custom. This establishment was built in 1661, and boasts superb architecture and green tile-work to the front and side elevations.

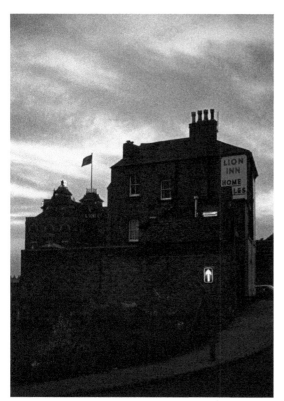

'The Lion' Mosley Street, Basford, 1982. This pub was very much a 'regulars' pub in the 1980s, with several small rooms, situated right next to Shipstones brewery, although ironically its beer was supplied by Home Ales of Daybrook, a few miles up the road!

'The Lion', 2008. Today, lush foliage frames the pub car park, the former site of a Shipstones corner off-licence kept by Elizabeth Gimson in the 1950s. This establishment was recently refurbished, with its multiple rooms knocked though into one, and boasts a glass-topped viewing well which offers customers a glimpse into the cellar. The tram stop is on nearby Shipstone Street, and superb real ales and local blues bands make this pub an unmissable gem for anybody interested in a pleasant drink, without worrying about driving home.

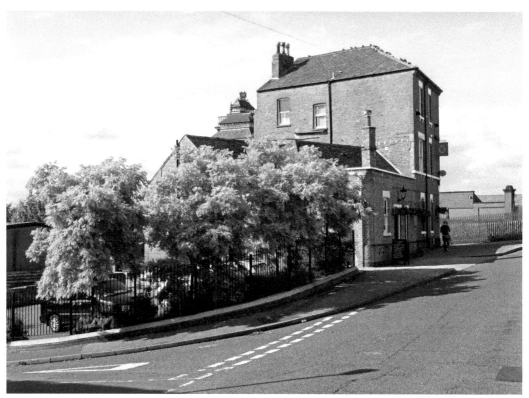

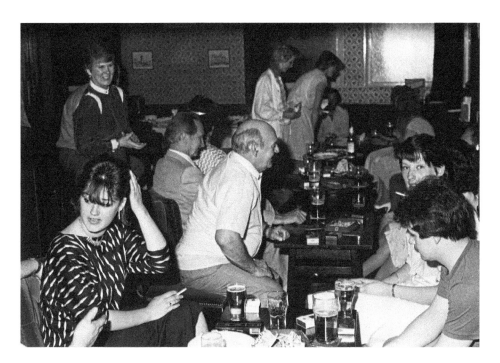

Customers at the 'Smiths Arms', Radford Road, Hyson Green, 1985. Landlady Fran is visible in the background on the left of this picture. Items on the table at the front of the shot include a Halina camera, empty packets of Scampi Fries, and plastic party plates.

Former 'Smiths Arms', building, 2008. This building was a pub as far back as 1936, when the licensee was William Yeomans. Two doors away was a pub called the New Inn. Now the pub has been turned into a local community centre.

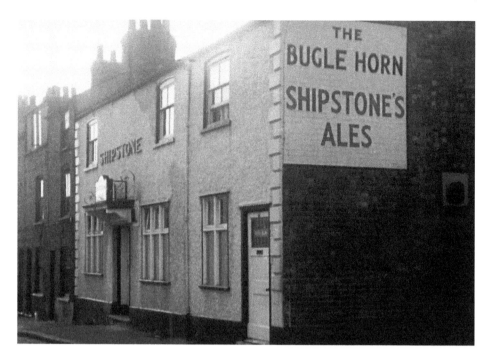

The 'Bugle Horn' pub, Schooner Street, Radford, 1965. This pub was known as 'The Nick' because of its small bar. It is said that, in the 1950's, a customer's wife in the adjoining property would knock on the pub wall to let the husband know his meat pie supper was ready!

Cleveland Close, 2008. The middle of this grassed area is the approximate site of the old 'Bugle Horn', now occupied by a 1960's flats complex. This patch of grass would have been relished by the children of Schooner Street in the 1960s.

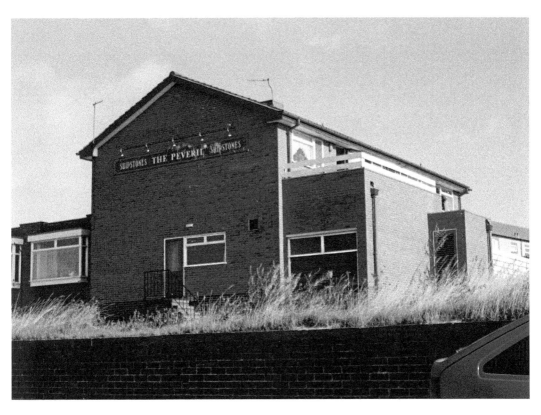

The 'Peveril' pub, Beacon Hill Rise, St. Ann's, 1985. This Shipstones pub was opened in 1975, after the Gordon Road area was cleared in the early 1970's. Local ale houses lost through demolition in this period included: 'The Robin Hood Arms', 'Sir Colin Campbell', 'The Devonshire Arms', and 'Alfred The Great'.

Beacon Hill Rise, 2008. The pub was recently rebranded 'The Bollywood', but recently fell into disrepair and has since been demolished. The glimmering rooftops in the background belong to houses branching off Carlton Hill in Sneinton, located on Denstone Road, Worksop Road, St. Cuthbert's Road, and St. Chad's Road.

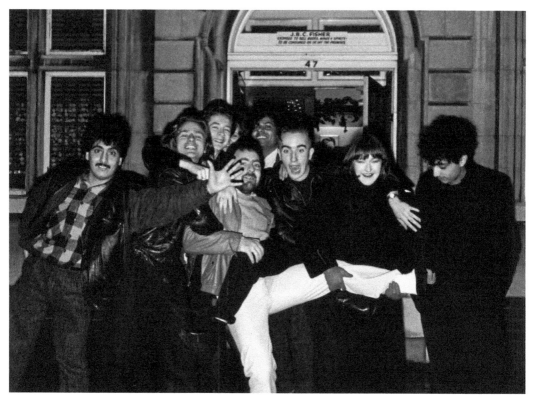

Jacey's Bar. Heathcoat Street, Nottingham, 1989. Here Pete Clark (centre) and friends are enjoying a night out at this popular venue. Ernest Button was the landlord in the 1930s, when it was called The Old Plough, but by the 1980s it was a popular pub for New Romantics and lovers of alternative music. Posters of the time advertised the 'Tizer', a cocktail of ice, vodka, rum, blackcurrant and lemonade on sale for just £1.

Former Jacey's Bar, 2008. The pub has since been rebranded as 'I-Bar', and more recently 'OHM', but now has a 'To Let' sign outside it.

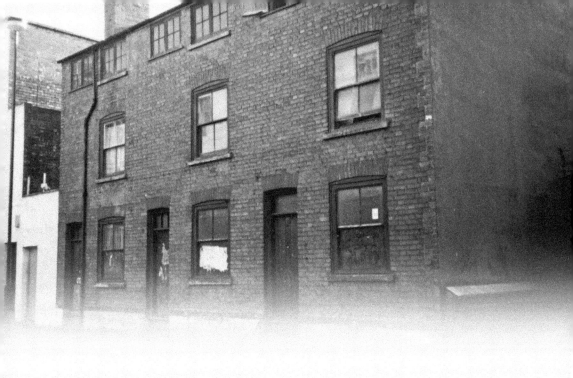

chapter 6

Architecture

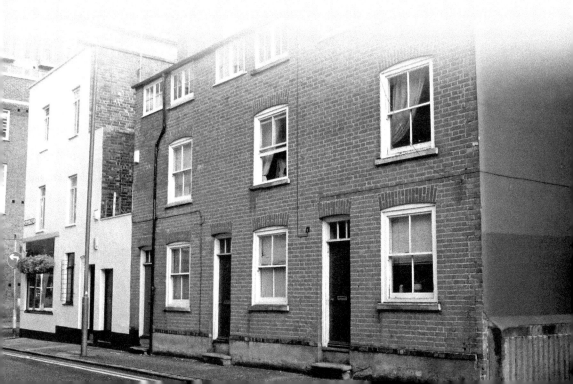

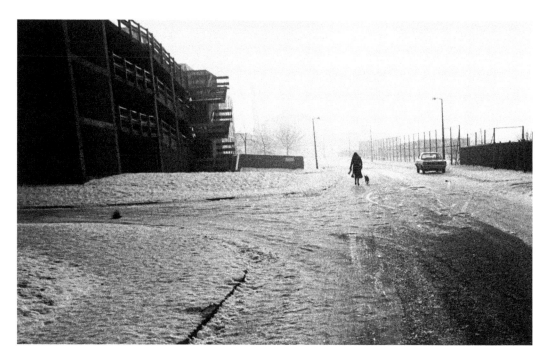

Snow on Norton Street, Radford, 1982. Norton Street Car Park can be seen on the left. Before this area was redeveloped in the 1960s, these streets were a melting-pot of potato merchants, midwives, dress makers, steeplejacks, cycle hands and printing workers.

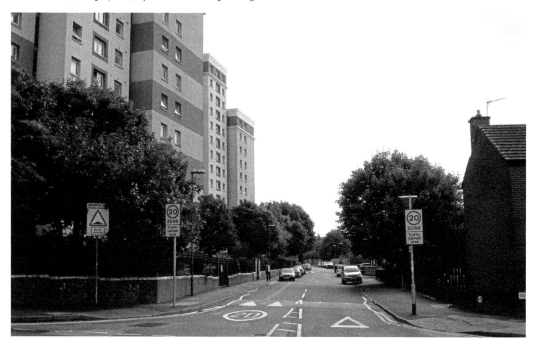

Norton Street, 2008. Traffic has now been calmed, for the school situated on this road. The recently renovated Woodlands flats are visible on the left. New developments such as Leroy Wallace Avenue have been built on the site of Edinburgh Street and Mitchell Street.

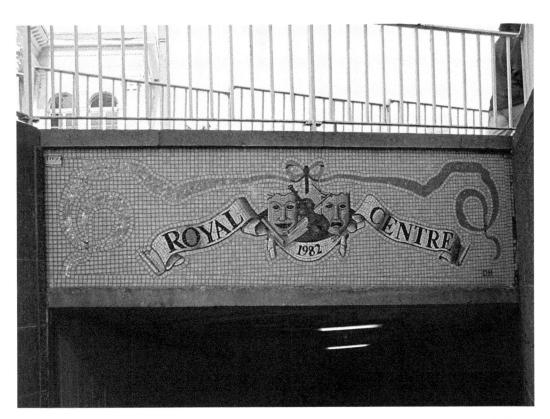

Subway Mosaic, Market Street, Nottingham, 1985. This underpass led to a newsagents stall and public toilets, and allowed the casual pedestrian to pass under Parliament Street. Many of these subways have now been filled in, partly as a result of disabled access issues and rising crime. The mosaic commemorates the building of the Royal Centre in 1982, and bears the initials 'DH'.

Market Street, Nottingham, 2008. The Theatre Royal is the cream coloured building to the left, with the modern Cornerhouse development visible to the right. Nottingham's buses are all colour-coded, this one is an 'Orange Line'. The building to the right is a camera retailer, but seventy years ago this was home to Kent and Coopers piano dealers, Darby's glass warehouse and Café Buols' confectioners.

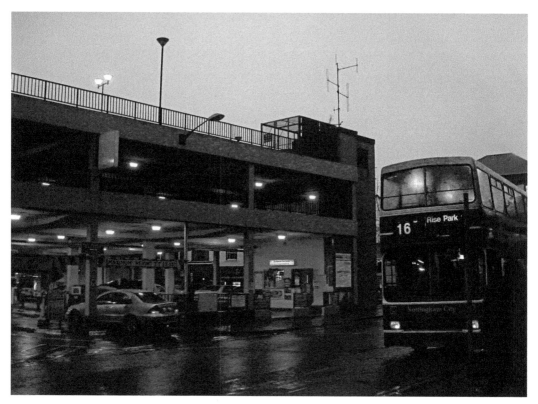

Trinity Square, Nottingham, 1999. This car park was built in the 1960s on the site of a church. An underground section of this car park also housed the Traffic Control Division. Just out of sight behind the bus is Peppers Hair Salon, whose mens' hairdressers was contained within a wood-panelled room, and displayed the slogan 'Peppers Are Hair', before its recent refurbishment.

Trinity Square, 2008. A tiled plaza and seating area now stands in place of the ageing car park, which was pulled down a couple of years ago. A local sandwich shop offered a 'Builder's Special' breakfast, during the construction of this area. The glass canopy to the right belongs to the 'Cornerhouse' complex.

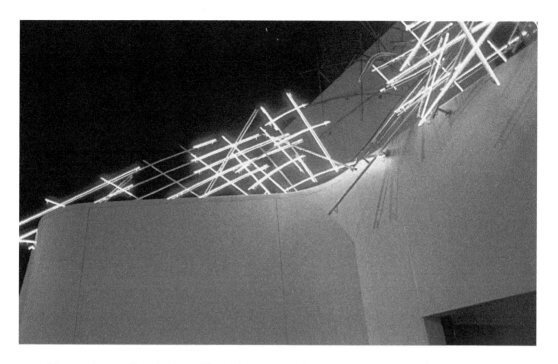

Neon sculptures, Royal Centre, Nottingham, 1984. These were commissioned from sculptor Ron Haselden, but were taken down in the late 1980s. The Centre was opened in 1982, and stands on the site of the old Empire Music Hall, which was demolished in 1969.

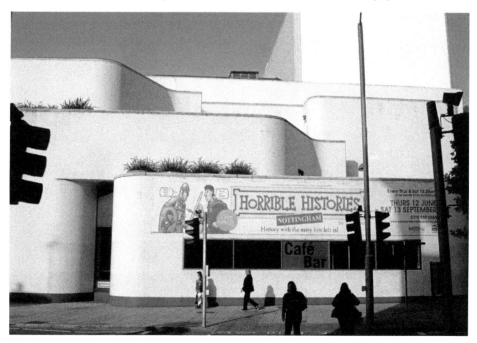

Royal Concert Hall, Nottingham, 2008. This venue has now had a name change, and plants occupy the space where the sculptures once stood. 'Langtreys' pub is situated opposite, and is popular with Nottingham folk for pre-theatre evening drinks.

Demolished Viaduct, Sneinton Hermitage, 1991. A Ford Sierra estate car is passing the Smirnoff vodka advertisement, on its way from the City Centre. Forty years before this photograph was taken, this road would have been host to a dancing school, a café, a wallpaper merchants, and several fruit shops, bakers and greengrocers.

Sneinton Hermitage, 2008. The new estate contains the houses of Marham Close and Ardmore Close, built on the site of the viaduct. Sneinton was the target of air raids during World War Two, with the Meadow Lane industrial area being hit directly by bombs.

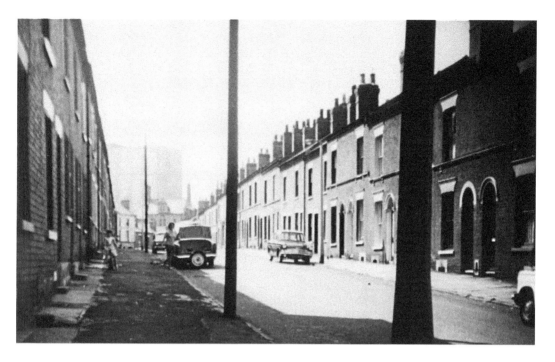

Ortzen Street, Radford, 1973. This street ran from 3 Southey Street to 48 Peveril Street, and was pulled down in the early 1980's. Just visible at the far end of the street is the old Marquis of Waterford pub and new flats, built on Alfreton Road in the 1960's.

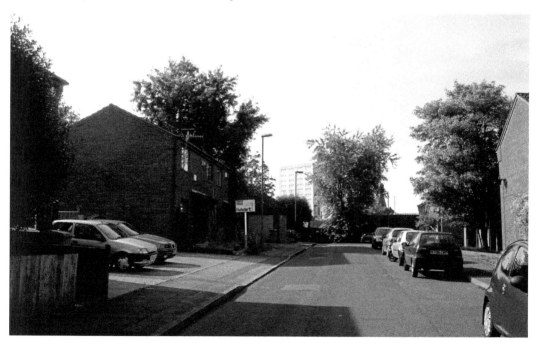

Ortzen Street area, 2008. This end of Ortzen Street has now been rebuilt and renamed Elmore Court. The old Ortzen Street was mainly residential, with over seventy houses.

Lincoln Street, Nottingham, 1986. Numbers 30, 32 and 34, seen here in disrepair, were residential properties, but very close to industry, such as Gilmans' joiners, Gibson's hosiery factory, and Pendred Hairdressing, trading here in the 1950s.

Lincoln Street, 2008. Today, the cottages have been renovated sympathetically, and provide a sharp contrast to the modern apartments on George Street in the background, converted from a former Post Office building. The shop on the corner is the former Trent Valley Paint & Varnish Company.

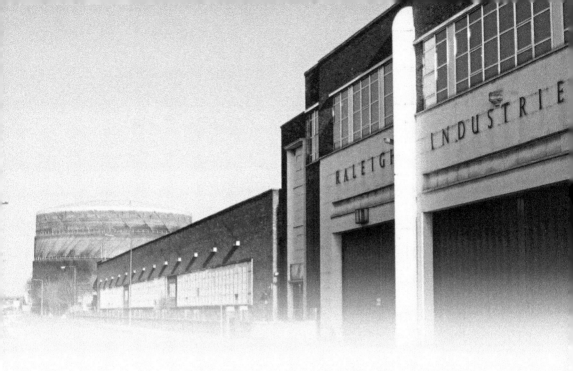

chapter 7

Raleigh Industries

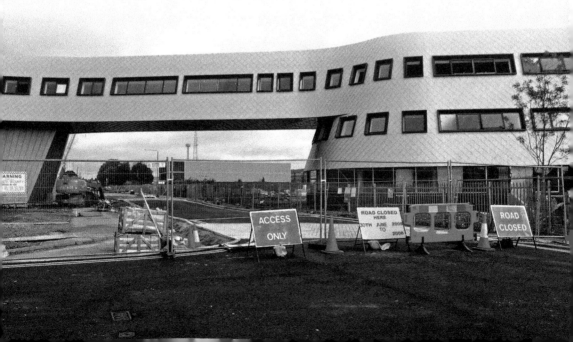

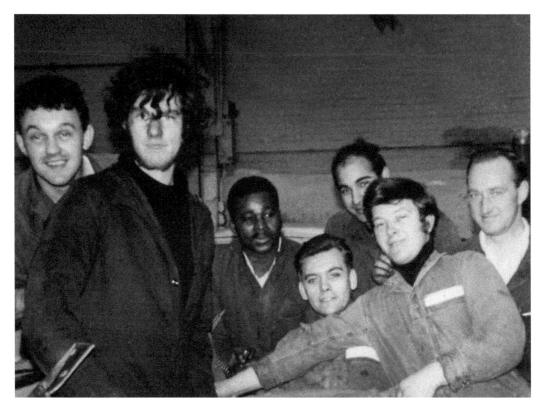

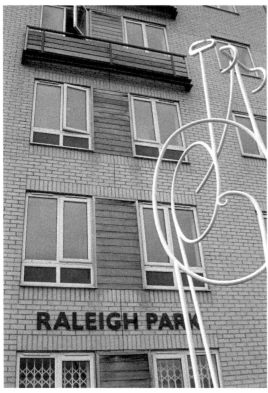

Workers at Raleigh Industries, Radford, Nottingham, 1966. Apprentices in the 1960s were often subjected to practical jokes, such as being sent for a 'long weight', or a 'tin of pinstriped paint'. A worker once apologised for being late, as he had fallen down two flights of stairs, and was told sternly 'You should have got here quicker then!' Despite this, Raleigh was a great place to work, with a family atmosphere and great camaraderie, and many workers started at fifteen and worked there till retirement.

Raleigh site, Ilkeston Road, Radford, 2008. New student developments have sprung up here, and give a nod of recognition to Raleigh's industrial past, with a cycle sculpture at the front, and a block named 'Sillitoe Court', after the famous Nottingham author. Just opposite this building, the former Chettles Yard site is now being developed.

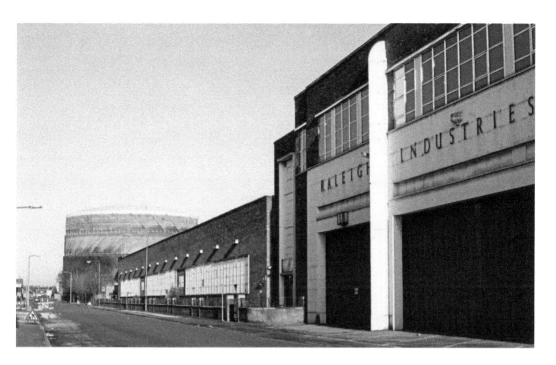

Raleigh Industries, Triumph Road, Radford, 1989. This was the last Raleigh building to be demolished, in September 2003, and signalled the end of cycle production in the Radford area. Raleigh now has a warehouse at Eastwood, on the outskirts of Nottingham.

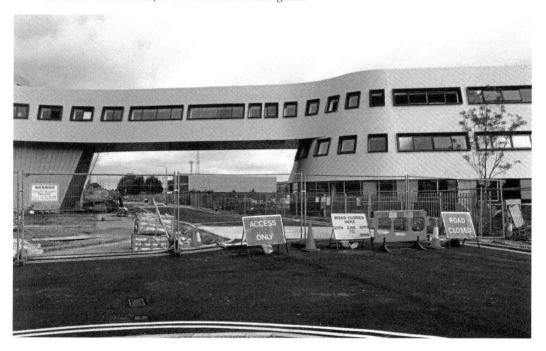

Triumph Road, 2008. Construction of the University of Nottingham Gateway Building is taking place, which, when completed, will offer wireless connectivity and networking, through the University's 'Supercomputer', the second biggest in Europe.

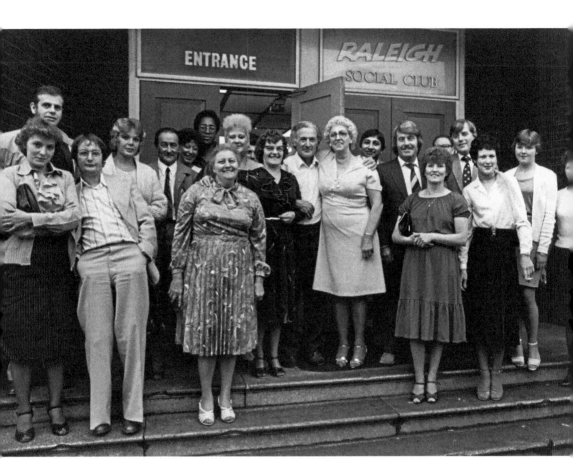

Raleigh Social Club, Faraday Road, Radford, Nottingham, 1979. Assistant Manager Joe Lacey (centre) and customers pose for a photograph outside this popular club. This was set up to provide a meeting place for Raleigh cycle workers, and was located just opposite the main factory on Faraday Road. Facilities included two full size snooker tables and a stage where groups would play on a Thursday and Saturday night. The famous Kershaw's Cockle Man would circulate amongst the regulars, selling tiny pots of seafood, such as whelks, with his cry of 'Cockles, Mussels!'. One Raleigh employee was rumoured to put half his wages through the fruit machines every week. Club manager John Fayes' closing-time cry of 'Come on you lot, haven't you got homes to go to?' was legendary! My father and I spent many happy hours at this club, and I often tell the story of how I could go out and have a few pints of beer, followed by fish and chips, and still return home with change from a fiver. Raleigh also provided an Athletic Club at Wollaton (see page 78) and a Christmas Party for employees' children at the Raleigh Ballroom on Lenton Boulevard.

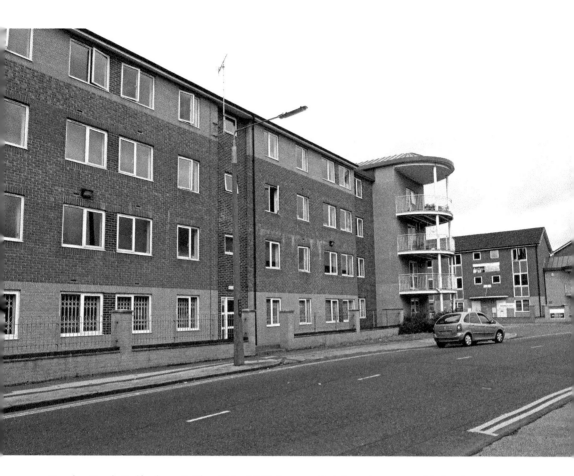

Faraday Road, Radford, 2008. The old Social Club was pulled down in 2000, and in its place now stands the student community of Raleigh Park. a modern, custom-built student village with 1,168 rooms for undergraduates and postgraduates. It consists of blocks of flats for groups of between four and six students. The site offers laundry facilities, secure cycle storage, parking, security, bar, and common room. The turning to the left marks the site of the old Raleigh Gate 4. In the 1950s, this area was home to the Raleigh Canteen and Steel Store. The working week at that time was 44 hours, 7.30am–12.30am, then 1.30–5.30pm. The average wage then would have been £1, 15 shillings. More student housing has now been built further up the road on the right, on the old site of Camm's Coaches. When we were at school in the 1970s, we called these coaches 'Camm's Collapsibles' because of their unreliability.

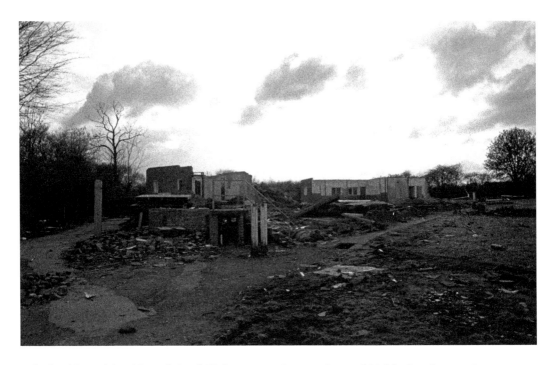

Raleigh Athletic Club, Old Coach Road, Wollaton, 1986. In 1963, Stan and Iris Northern became the stewards of this popular club, which offered tennis, cricket, bowls, football, badminton and archery facilities. Later, Les and Irene Eley took over as licencees.

Raleigh Athletic Club site, 2008. A new estate of executive houses has now been built on the Raleigh site, and despite the prestigious location, there is graffiti on the street sign.

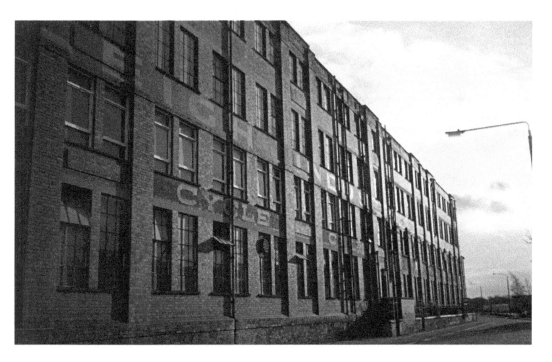

Raleigh Cycle Company, Faraday Road, Radford, 1981. Four storeys of industrial muscle tower into the skyline at dusk, on a warm summer night. In 1964, a survey of workers' cycles in the compound showed that only 14 out of 200 cycles parked there were locked up!

Faraday Road, 2008. Situated directly opposite the old Raleigh Social Club, (see page 76), this area has also been developed residentially from the old cycle factory site. And so, the rumble of factory machinery has been replaced by the rumble of the vacuum cleaner.

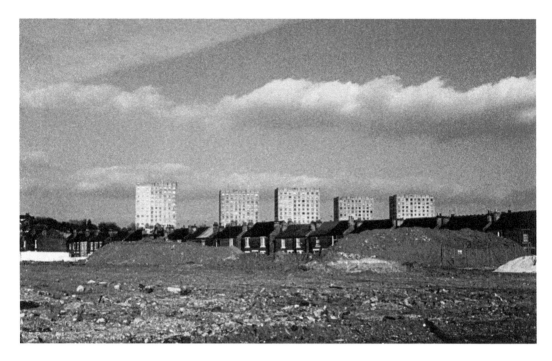

View from Faraday Road to Cycle Road, Radford, 1990. The Lenton Flats peek out from the piles of rubble created by the demolition of the Raleigh 3-Speed Hub Factory. These flats, built on the site of Kyte Street and Willoughby Street, featured in the opening sequence of the 2007 film 'Control'.

Kittiwake Mews, Radford, 2008. Now the view to the flats has been obscured by a new estate, making Faraday Road almost entirely residential.

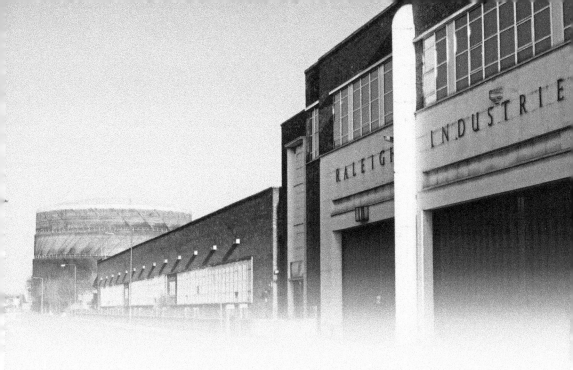

chapter 8

Industry

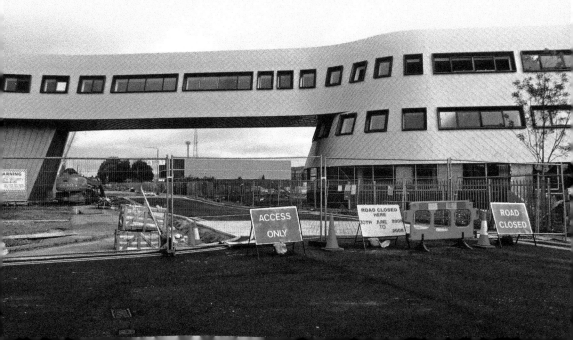

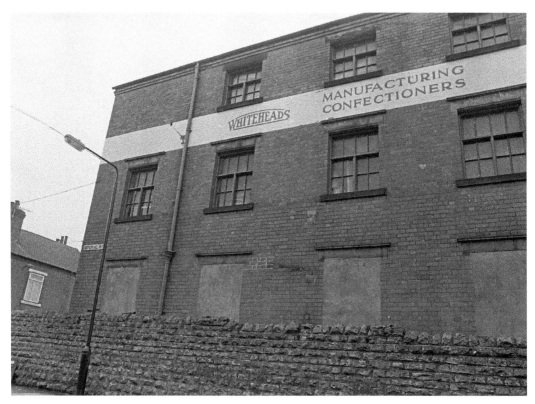

Whitehead's Confectioners Factory, Imperial Street, Bulwell, 1985. This building was originally the Nottingham Co-operative Society's Cabinet & Upholstery Department, but by the 1950s was already established as a confectioners. Other local sweet manufacturers in existence during this period included The Lilac Time Confectionery Company, Barnetts of Radford, William Craven of Woodborough Road, and H. Paynes of Pym Street.

Former Whitehead's Factory, 2008. From what I can gather, the building is now mostly vacant, fenced in by sheets of plywood. Although Nottingham City Centre is being refurbished, elderly buildings on the outskirts such as this one seem to have been forgotten.

John Player and Sons factory yard, Hartley Road, Radford, 1984. The chimney was pulled down in 1986, and was part of the huge Player's cigarette factory, built on the site of a former school and vicarage, which along with the Raleigh Cycle Works, dominated the Radford area up to the 1980's. Land for cigarette factories was purchased in the Radford area as early as 1881, and by 1972 Player's was supplying Britain with a third of their cigarettes. Brands such as No.6, No.10, John Player Special and Gold Leaf dominated the UK smoker's market in the 1970's.

Hartley Road/Lonsdale Road junction, 2008. Today, the Player's yard is now the goods entrance for a retail park, and lacks some of its former industrial charm. The corner shop was the former home of Joseph Frost the grocer, who took over from Samuel Hogg in the 1940s.

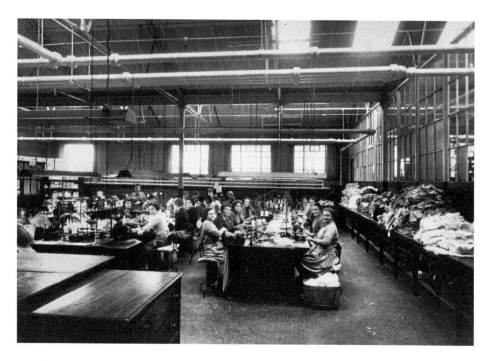

Woolpack Hosiery Works, Triumph Road, Radford, 1950s. Just after the war, this road consisted mainly of factories, with just one resident on the street, Harry Briggs at number 85.
A 'sewing machine needle through the finger' was a constant workplace hazard in those days.

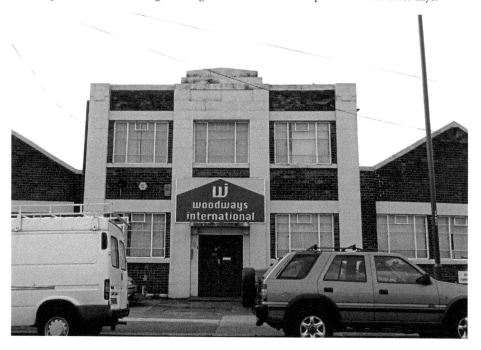

Woodways International, Triumph Road, 2008. One of just a few old buildings left on this road, I wonder just how long they will last, as the nearby University Jubilee Campus continues to expand at an alarming rate.

Demolition of A C Gill's Factory, Fletcher Gate, 2001. This former hairnet factory was bulldozed quite recently, and with it went a long standing textile tradition in the Lace Market area. This district was first named "The Lace Market' in 1847, and at its peak, at the outbreak of WW1, there were over 1,500 lace factories in this part of Nottingham. Local lace manufacturers trading in the 1930s included: Adcock's, Barton & Tardiff, Bentley & Clifton, Day & Brown, Fred Stapleton, Harold Hammersley and Stern & Stern.

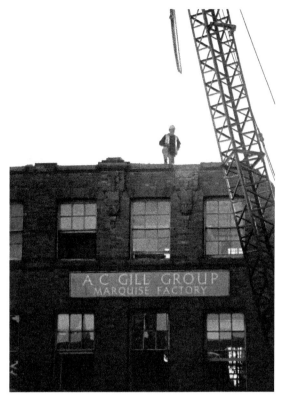

Fletcher Gate, 2008. Shops have now opened below the Fletchergate apartments complex, which stretches all the way round Warser Gate and St. Mary's Gate, ending in a seating area facing New College, Nottingham. The Lace Market area is now home to many bars, clubs, and graphic design companies, often located in former lace factory premises.

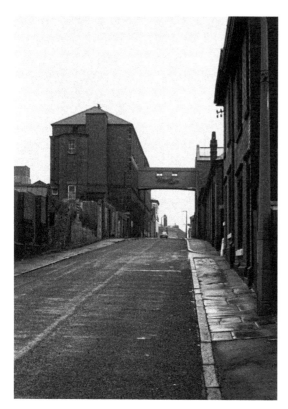

Rawson Street, Basford, 1984. The houses on the right were terraced cottages owned by Shipstones Brewery, rented to workers and painted a corporate red colour. It is suspected that the large building on the left was previously the General Plating Company, just in front of the 'Raven Inn'. The wall on the right bears the inscription' Weldon and Wilkinson 1914', and records state that this was indeed a bleaching works. Original paving can be seen on the right, fronting up to the terraced houses.

Rawson Street, 2008. The buildings on the right have been replaced by Draymans Court, a new housing development, which still retains the Shipstones 'red' theme. To the left are small industrial units.

Demolition of Myfords Lathe
Factory, High Road, Beeston, 1988.
The Myford Engineering Company was
founded in 1934 by Cecil Moore in a
single room within this factory. He quickly
expanded and within a short space of
time, took over the whole building. The
Myford ML7 lathe was introduced in
1946, and proved a popular model, staying
in production until 1979. The Beeston
area is also home to the Royal Mail
Sorting Office, and the internet company
Webfusion.

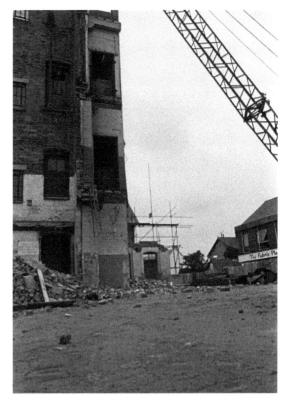

High Road, Beeston, Nottingham, 2008.
Today, the Fabric Place shop remains, but
the old factory site has been converted to
use as a car wash facility. Myfords are still
trading today, on Wilmot Lane.

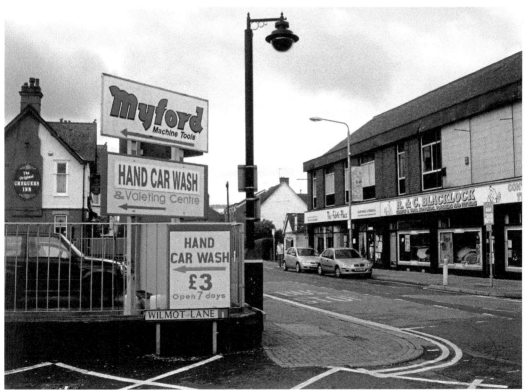

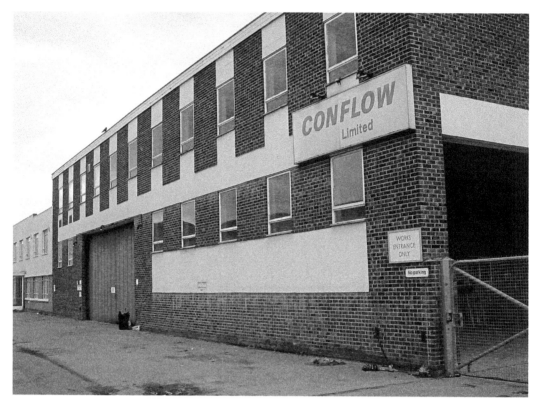

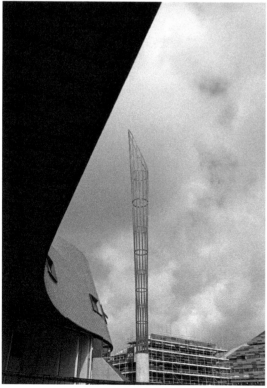

Haydn Nilos Conflow Factory, Triumph Road, 1989. This famous valve manufacturers was situated next to the Clearway company, and the cycle gear makers Sturmey-Archer, all demolished in the late 1990's to make way for the Nottingham University Jubilee Campus.

Triumph Road, 2008. This new sculpture, named 'Aspire', was designed by Ken Shuttleworth and is sixty metres high. Standing on the Nottingham University Campus and fashioned from orange and red steel, this work cost £80,000 and was funded anonymously. This is, at present, Britain's tallest free-standing sculpture.

chapter 9

Leisure

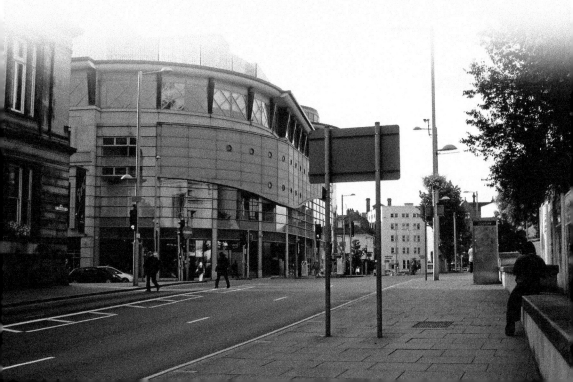

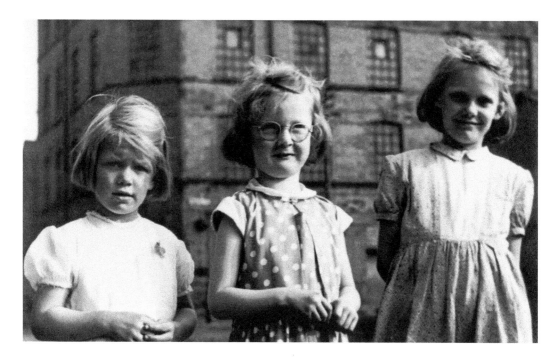

Freeth Street, Sneinton, Nottingham, 1957. (L-R), cousins Jennifer Smith, Linda Bedford and Janet Smith in front of Bitterlings factory. Bitterlings were a local manufacturer of butchers' aprons, and were located off Meadow Grove.

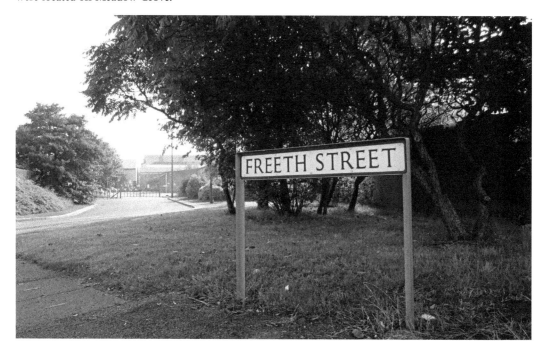

Freeth Street area, 2008. Now clusters of industrial units have been built along the cleared site of Freeth Street. When the previous photograph was taken, this street had amongst its industries the wonderfully named 'Fina Oil Wharves' petroleum merchants.

Carnival procession, Tamworth Road, Long Eaton, 1981. Here, the float from the Victoria Inn passes a cigarette advertisement, 'Players Please', a superb example of copywriting word-play. The ladies appear to be drinking half-pints of beer. Almost thirty years later, the idea of four-foot high cigarettes on an advertising billboard on the High Street is unthinkable.

Tamworth Road, Long Eaton, 2008. Today this section of the street still retains its village charm, although the Gas Showroom opposite has now been converted into a public house. At the end of this road is the area known as 'The Green', where a bus to Nottingham can be boarded.

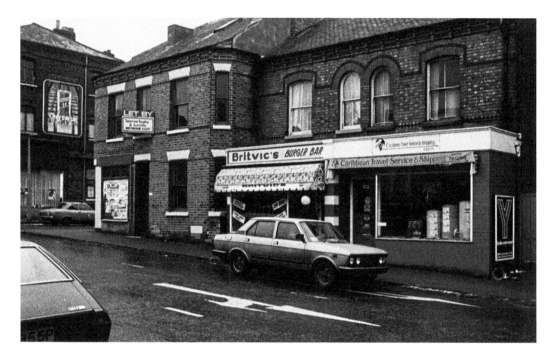

'Caribbean Travel Service & Shipping', Bentinck Road, Radford, Nottingham, 1982. This shot displays a curious mixture of advertising materials, ranging from motor oil to underpants. The side road to the left is Birkin Avenue.

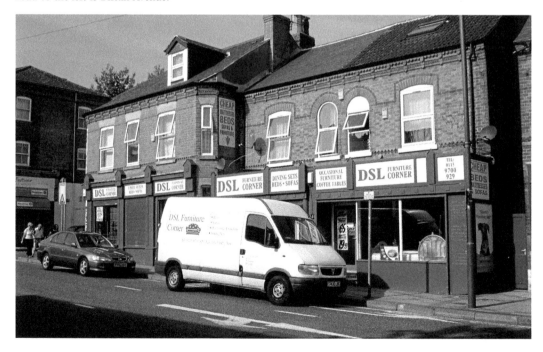

Bentinck Road, 2008. Now the travel agents has gone, but has been replaced by another store catering to the leisure industry, a bed shop. The business has extended all the way to the corner shop on the left, which was Mrs Annie Brown's hosiery shop in its previous life.

'Nottingham Evening Post' building, South Sherwood Street, Nottingham, 1982. This building was occupied by Nottingham's premier local newspaper, until relocation to Castle Wharf in 1998. The bus poster is advertising Falmers Jeans.

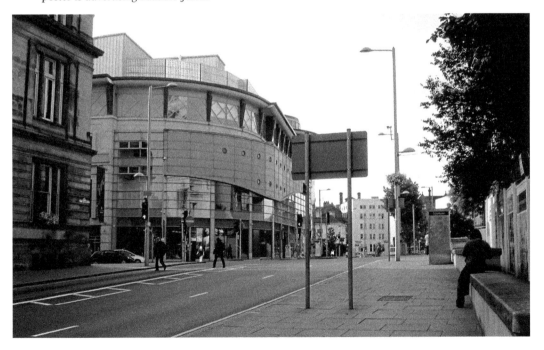

South Sherwood Street, 2008. The old newspaper building has since been demolished, and the new Cornerhouse leisure complex stands in its place, which boasts a cinema, several restaurants and the impressive Saltwater rooftop bar, which offers a fine panorama of night-time Nottingham.

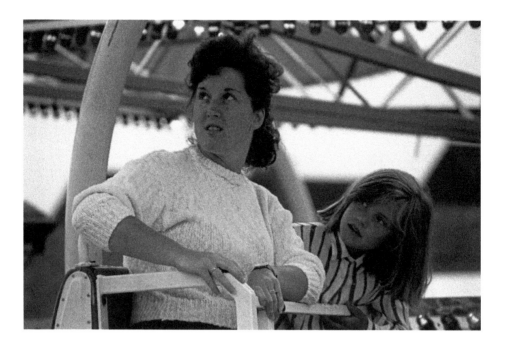

Nottingham Goose Fair, 1989. Just what the people in the picture are looking up at is uncertain, possibly the dizzy heights of another ride in full swing? The Fair's rides got ever more adventurous in the 1980s, and some were sure to make loose change in pockets come cascading to ground level, as riders were suspended upside down.

Goose Fair site, 2008. Braidwood Court, a high-rise block spared by the 1980's demolition of the Hyson Green Flats, has now been redeveloped as The High Point.

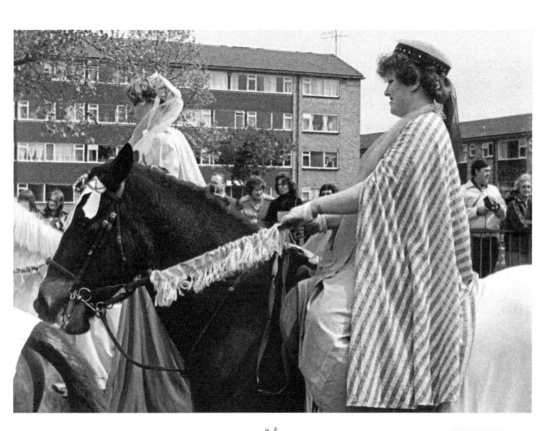

Horse riders, Tamworth Road, Long
Eaton, 1981. This shot of the Long Eaton
Carnival shows the Romorantin Place
Flats situated next to the 'Tiger' pub, with
spectators obscuring the water fountain.
In 1931, J W Martin, of the Long Eaton
Hospital Carnival Committee made this
comment about the Carnival:
*My final Carnival message is an appeal
to every man, woman and child in Long
Eaton to be a cog in the Carnival wheel.
If they determine to be so, the wheel will
go smoothly and the utmost success will
be ours.'*

Tamworth Road, Long Eaton, 2008. Now
the water fountain no longer functions, and
many of the shops around this area appear
to be derelict. In his youth, the younger
(and fitter) author often ran home eleven
miles from Long Eaton to Nottingham,
after missing the last bus home.

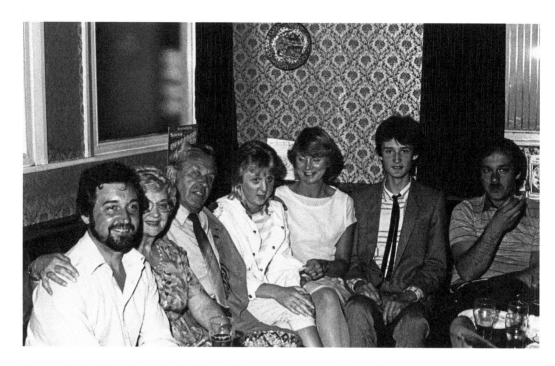

Party at the 'Radford Arms', Radford Road, Hyson Green, 1985. The Radford Arms dates from 1887 and was later called 'Zanzibar'. In 1985, there were three pubs open on this section of Radford Road: The Langham, The Smith's Arms, and this one.

Former 'Radford Arms', 2008. This pub was previously supplied by Ansells Brewery, and the dentist to the left was a Tesco supermarket in the 1970s. Now it has been converted to an Indian restaurant, with a impressive display of chrome.